The Kalmbach Art Collection
PAIRING WORDS AND IMAGERY

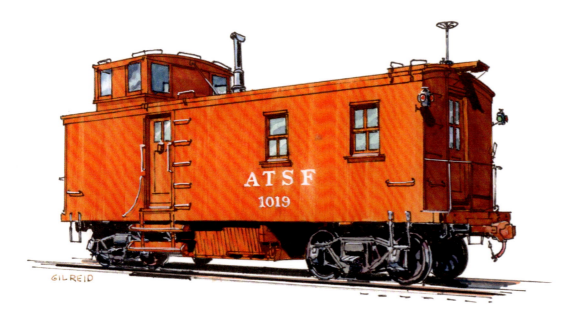

The Kalmbach Art Collection

PAIRING WORDS AND IMAGERY

Lead essay
Kevin P. Keefe

Additional essays
Adrienne Evans
Lisa Hardy
James R. Kieselburg

Interviews
Kevin P. Keefe
David Lassen
Rob McGonigal
Brian Schmidt

Captions and other text
Scott Lothes

Paintings and drawings
Phil Belbin
Chuck Boie
Allen J. Brewster
Kent Day Coes
Howard Fogg
Olindo Giacomini
George A. Gloff
Steven R. Krueger
Lawrence O. Luser
Pat McMahon
Gil Reid
Ted Rose
Bob Sherman
John Swatsley
Richard Ward

Center for Railroad Photography & Art
Madison, Wisconsin

In gratitude

**The Kalmbach
Art Collection**
Pairing words and imagery
Copyright © 2025
Center for Railroad
Photography & Art
railphoto-art.org

All rights reserved
Printed in the U.S.A.
First edition

Book design and
composition:
Scott Lothes

ISBN 978-1-7345635-4-2

Front cover:

Howard Fogg
*Steam and
Steel Winterset*
13x10 inches, 1947
Ink wash on paper
Kalmbach-001

Published in *Trains*,
January 1948

Previous spread:

Gil Reid
Santa Fe Caboose
8x12 inches, 1990
Watercolor on board
Kalmbach-006

Rear cover:

Ted Rose
Only Yesterday
14x20 inches
Watercolor on paper
Kalmbach-003

Published in *Trains*,
November 1990,
50th anniversary issue

VISITING THE OFFICES OF Kalmbach Publishing Co. for the first time—when I was a budding photographer and writer still in my twenties—felt like Charlie Bucket stepping into Willy Wonka's chocolate factory in that famous Roald Dahl story. I had grown up reading *Trains* and *Model Railroader* magazines; the place and the people that made them seemed almost magical. Reinforcing that notion, in almost every office and around almost every corner, was the artwork on the walls.

Some of the best railroad paintings and drawings ever created hung in nearly every place I looked. Any one of them could have been the centerpiece of a living room, and as my tour continued, I kept seeing more.

Never could I have imagined then that, less than two decades later, I would lead the organization charged with the long-term care of that artwork. A village of people helped make it possible for the Center for Railroad Photography & Art to take on the Kalmbach Art Collection, and we extend our great thanks to everyone involved.

Kevin P. Keefe was the bridge between the two organizations. He serves on our board of directors and spent most of his career with Kalmbach, notably as editor of *Trains* magazine and then as the company's vice-president, editorial. He championed the collection to us, and he brought our case to the Kalmbach executive suite. He knows the collection better than anyone, and he lent us that expertise by writing the lead essay for this publication.

We thank Kalmbach Media and those who made the decision to entrust their artwork to our care, including Dan Hickey and Martha Lundin. We are equally humbled and inspired by your confidence. We extend our gratitude to everyone who came through Kalmbach and supported great railroad art and imagery, from the editors and designers who requested it, to the managers and executives who approved it. In particular, we acknowledge the late, longtime editor David P. Morgan, whose image appears in the Ted Rose watercolor on the rear cover, and whose legacy is ever-present in the visual culture of railroading.

We thank the Kalmbach staff members who spoke so freely and enthusiastically with us about the collection and what it means to them: Roger Carp, David Lassen, Rob McGonigal, and Brian Schmidt. I extend my personal thanks to each of you and to the many other Kalmbach employees who have done so much to support both the CRP&A and me through the years: Diane Bacha, Andy Cummings, Tom Danneman, Drew Halverson, Matt Van Hattem, Mark Hemphill, Scott Krall, Kathi Kube, Diane Laska-Swanke, Bob Lettenberger, Angela Pusztai-Pasternak, Nastassia Putz, Steve Sweeney, Carl Swanson, Mike Yuhas, and the late and deeply missed Jim Wrinn.

Our community of members and supporters at the CRP&A has powered our growth and brought us to the position to take on collections like this one, and each of you have our great thanks. The full listing of our board and staff appears on the last page; Bon French and Rich Tower merit special recognition for their transformative generosity. The Elizabeth Morse Genius Charitable Trust, the Railway & Locomotive Historical Society, the National Railway Historical Society, and the Lexington Group in Transportation History have all supported our efforts with grants. Every member of our staff contributed to this effort, from transportation to digitization to research. And none of this could have happened without our principal founder, the late John E. Gruber, whose vision and efforts brought the CRP&A into existence.

Finally, and most importantly, we thank the artists, who faced down blank paper and canvas, and on them applied their immense talents to create the works reproduced on the pages that follow.

—Scott Lothes, President and Executive Director

Table of contents

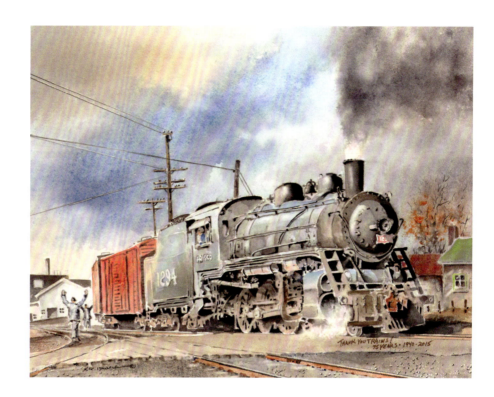

Steven R. Krueger
Frisco 1294
13x17 inches, c. 2015
Watercolor on paper
Kalmbach-021

The artist painted this as a gift to *Trains* for the magazine's 75th anniversary. His inscription says: "Thank you, *Trains*! 75 years · 1940 – 2015."

Foreword	6
Fine Art…Workaday Roots	8
Gallery	18
About the Artists	72
Kalmbach Interviews	76
CRP&A Staff Perspectives	78
About the CRP&A	80

Foreword

James R. Kieselburg
Director, Grohmann
Museum at Milwaukee
School of Engineering

THE GROHMANN MUSEUM at Milwaukee School of Engineering is the debut venue for the exhibition *The Kalmbach Art Collection: Pairing Words and Imagery*, prepared and circulated by the Center for Railroad Photography & Art. Its display dates at the Museum are from May 16 through August 18, 2025.

The Grohmann Museum is unique in that we are one of the few museums—if not the only one—that features exclusively the art of industry, labor, and human achievement. As such, we have a natural affinity for the railroad, its history, and its central role in the advancement of industry and technology throughout the nineteenth and twentieth centuries. Rail transport was integral to the developments of the industrial revolution, which in turn was the catalyst for the expansion of the railroad itself. Our history of showcasing and highlighting the art of industry demonstrates the inextricable link between the two. Seven of our fifty-seven feature exhibitions have focused solely on the railroad, while many others have included images of locomotives, bridges, and railways. Whether in industrial landscapes, depictions of engineering, infrastructure, construction, or agriculture, the railroad regularly takes center stage. Few engineering accomplishments speak to hard work and the industrial age like trains.

Equally unique to the Museum in many ways is the work of our friends at the Center for Railroad Photography & Art. That these two collections exist eighty miles apart is quite remarkable, and a wonderful opportunity for our patrons. Working first with founder John Gruber, and now with Scott Lothes and staff, we have forged a relationship that allows us to reinforce the mission of each through thoughtful presentations of rail art. Our previous collaborations include *Requiem for Steam: The Railroad Photographs of David Plowden* (2011), *Trains that Passed in the Night: Railroad Photographs of O. Winston Link* (2014), *Wallace W. Abbey: A Life in Railroad Photography* (2018), and *The Railroad and the Art of Place: Photographs by David Kahler* (2021). It seems that every three or four years we are presented with an opportunity to work with the Center, and here we are, right on schedule. However, the present exhibition represents a departure from photography and is the first to feature a variety of portraits of the railroad in painting and drawing.

The Kalmbach Art Collection—like the Grohmann Museum and the Center for Railroad Photography & Art—is truly one-of-a-kind. Assembled over the decades of Kalmbach's work as a leader in rail media and publications, it includes the work of many artists who

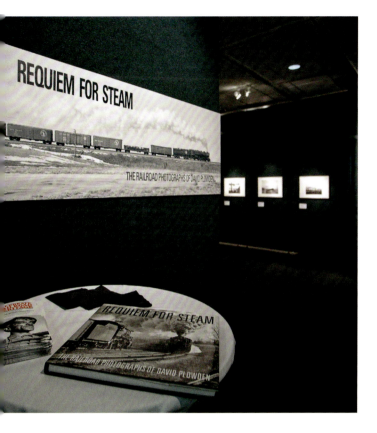 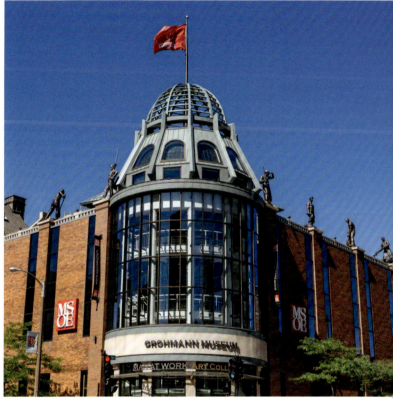

The Center for Railroad Photography & Art's exhibition *Requiem for Steam: The Railroad Photographs of David Plowden* at the Grohmann Museum in 2011, and an exterior view of the Museum in 2022. Photographs by Scott Lothes and courtesy of the Grohmann Museum

ultimately became household names among railfans—Ted Rose, Gil Reid, Howard Fogg, and many others. When I learned of Kalmbach's pending sale to Firecrown Media, my thoughts first turned to their collection. In fact, I inquired with some mutual friends on its availability in hopes to add it to the Museum's collection, only to learn a short while later that Scott and the Center had the same thought and were one step ahead. Once an agreement was in place, Scott wrote to inquire whether the Grohmann could be a possible venue for its inaugural display. He received our answer ten minutes later. Thus, it is with great pride and pleasure that we are able to feature this premiere public exhibition of Kalmbach Media's historic art collection.

We remain grateful to the Center for their friendship, collaboration, and continued contributions to both our exhibition program and the canon of railroad photography and art history. •

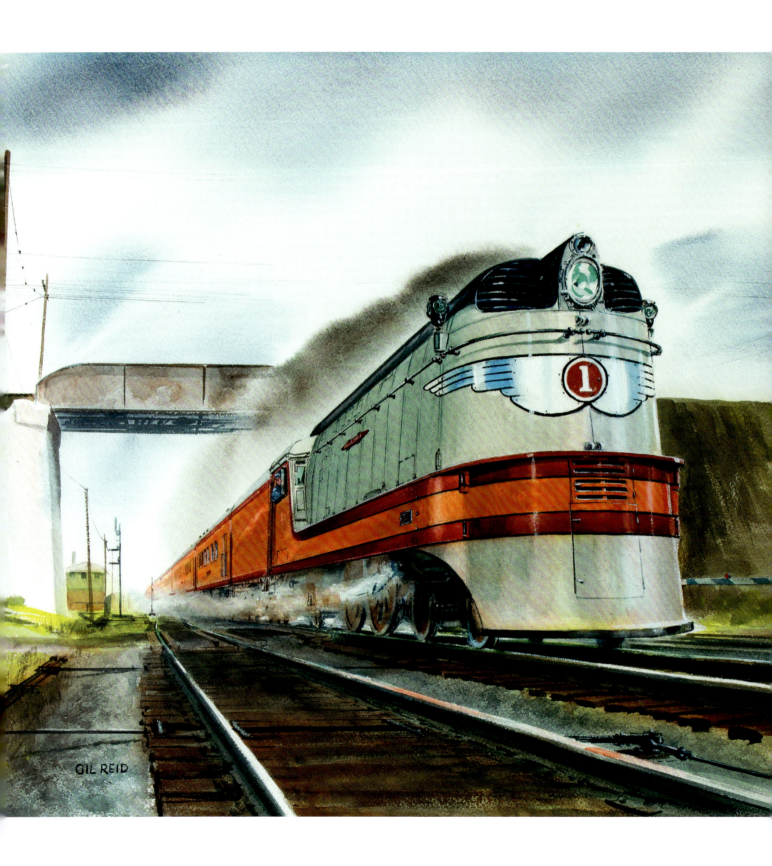

Fine Art... Workaday Roots

Over more than half a century, Kalmbach created a significant body of railroad art

Kevin P. Keefe
Board of Directors, Center for Railroad Photography & Art
Former vice-president, editorial, Kalmbach Media

Gil Reid
Berkshire at Midnight
17x25 inches, c. 1965
Watercolor on paper
Kalmbach-032

Published on the dust jacket of *The Nickel Plate Story*, by John A. Rehor, which had five printings between 1965 and 1994.

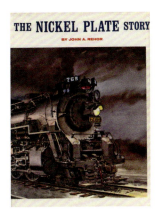

Gil Reid
Roaring Through Rondout
20x28 inches, c. 1970
Watercolor on paper
Kalmbach-055

Published on the dust jacket of Kalmbach's most successful hardcover book, *The Hiawatha Story*, 1970, by Jim Scribbins

Milwaukee Road Class A Atlantic No. 1 leads *The Hiawatha* through Rondout, Illinois, in 1935.

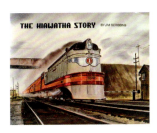

IN THE SPRING OF 2024, Kalmbach Media, the bellwether railroad publisher, announced it was going out of business, having sold most of its magazine brands to Chattanooga-based Firecrown Media. By mid-summer, all of Kalmbach's so-called "tracks titles"—*Trains*, *Classic Trains*, *Model Railroader*, and *Classic Toy Trains*, plus their attendant digital extensions—pressed ahead under new ownership. With the sale, Firecrown acquired considerable editorial assets, notably Kalmbach's famous David P. Morgan Memorial Library, with its thousands of books and some 100,000 photographs. It was a relief to know these priceless collections presumably were safe.

One detail of the sale was left unaddressed in the initial announcement from Kalmbach: what would happen to the company's art collection? The company was formed by Albert C. Kalmbach in Milwaukee in 1933 and over most of its ninety years in business either commissioned or produced in-house some of the most famous of all American railroad paintings, created by a who's who among the genre's artists. In total, Kalmbach Publishing (later Kalmbach Media) owned more than fifty original works of art, nearly all of them exhibited in the corridors and offices of its office buildings, first in downtown Milwaukee and later in Waukesha, Wisconsin.

I had a keen interest in these artworks. I admired many of these paintings since my teenage years as a *Trains* reader and later, over a thirty-one-year Kalmbach career, had the privilege of enjoying them nearly every day of my working life. All of these works carry some significance, although I definitely had my favorites. Over my eight-and-a-half years as editor of *Trains*, Gil Reid's monumental *Roaring Through Roundout* hung right outside my office door. Just down the hall was Ted Rose's transcendent watercolor from the cover of the book *Canadian Steam*. I was jealous of my colleague Jim Schweder, the company's technology boss, who had scooped up George Gloff's paired masterpieces of mixed media called *Rio Grande Revisited* (p. 52-53) and hung them in his first-floor office.

Not long after the news the company was folding came word from the office of Kalmbach CEO Dan Hickey: the art collection was not part of the transaction with Firecrown. For the moment, Kalmbach was keeping it. This prompted feverish consultations involving the Center's executive director, Scott Lothes, a couple of veteran board members, and myself. We all agreed: With Kalmbach facing liquidation, the best permanent outcome for the paintings would be acquisition by the Center, an established organization that could not

George A. Gloff
My Kind of Town
18x22 inches, c. 1967
Acrylic on paper
Kalmbach-002

Published on the dust jacket for *The Time of the Trolley* by William D. Middleton

The scene is Chicago's Randolph Street at Dearborn, the time is the theater hour on a rainy evening in 1930, and the artist knew how to leave space for a book title.

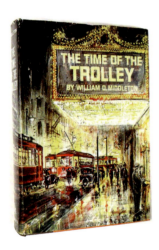

only properly preserve and protect the artworks but also make them available to the widest possible audience. Not incidentally, there existed numerous personal connections between Kalmbach employees and Center leadership and membership.

I arranged a meeting with Hickey and his top-notch assistant, Martha Lundin, and learned that Kalmbach was, indeed, looking for a good home for the art. When Dan said "we want to keep the collection together in memory of founder Al Kalmbach and his company," I felt a surge of relief. At Hickey's invitation, Scott and the Center's leadership team put together a proposal for Kalmbach's board. We didn't have to wait long for an approval, an extremely welcome decision despite the bittersweet back story. A couple of weeks later, I headed out to Kalmbach's headquarters to join Martha and the Center's crack acquisition team—Adrienne Evans, Inga Velten, and Lisa Hardy—to pack up the paintings and take them to Madison.

These works were not part of a corporate collection in the classical sense. They weren't purchased on the art market for art's sake, nor were they conveyed to the company by deep-pocketed connoisseurs, or suggested by interior design consultants. All of these works were created in the unglamorous, workaday routine of getting magazines and books out the door. Some were commissioned by the editors, leaning on their good relationships with outside artists rather than their ability to pay market prices. Many were painted on company time by intrepid members of Kalmbach's own art department, some of whom had separate reputations as stars of railroad art.

Four of those Kalmbach artists bear special mention. One of them was Gil Reid, a twenty-two-year employee, the company's assistant art director, and inarguably one of the top names in railroad art. Reid might be best known for his many years of producing paintings for Amtrak's large-format calendars. But he also made a name for himself with the covers of Kalmbach books such as *The Hiawatha Story* (the aforementioned *Rondout* painting), a night scene of a Berkshire steam locomotive for *The Nickel Plate Story*, and his Main Street small-town scene for *The Interurban Era* (which is not part of the collection). Gil worked in various media, although watercolor was his preferred approach, and his often-giddy paintings were animated by the artist's deep love of railroading.

Gil's longtime boss was George A. Gloff, for many years the company's corporate art director and a visionary leader for the art department. As a painter George was not nearly as prolific as Gil, but he had a

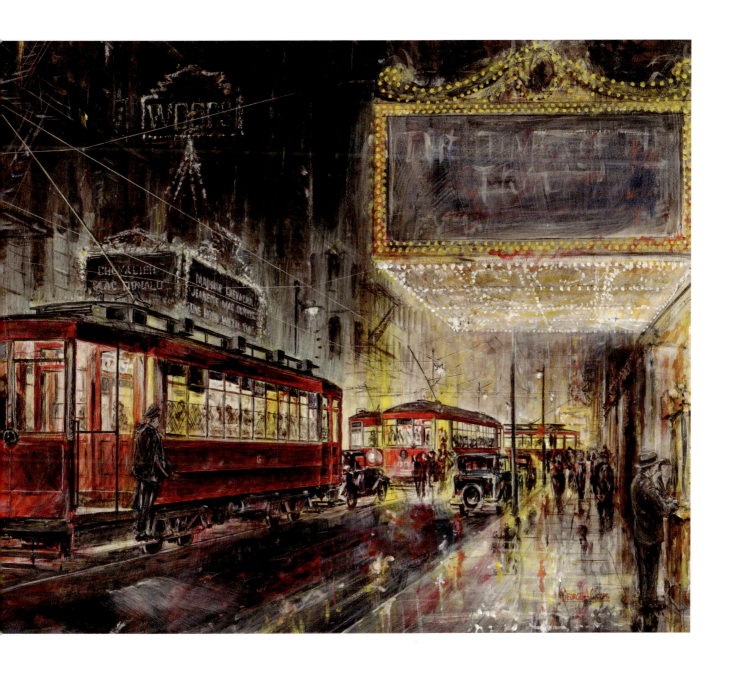

John Swatsley
Casey Jones, April 1, 1900
17x17 inches, 1999
Acrylic on board
Kalmbach-029

Published in *Trains*,
April 2000

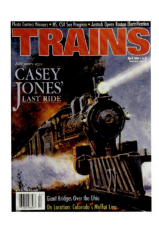

penchant for making large, complex works that, over time, drifted away from the strict illustrative approach of most railroad artists and toward something that might be called impressionistic. George's rain-spattered street scene for the book *The Time of the Trolley* beautifully portrays the power and mystery of Chicago's Loop, while his loose, bold approach on those two Rio Grande diesel-era paintings make you feel the power of mountain railroading.

Perhaps the brightest of all the stars of railroad art also had a brief season on the Kalmbach payroll. As a young college student at the University of Illinois in the early 1960s, Ted Rose managed a couple of years of summer jobs back at home in Milwaukee in the KPC art department. He no doubt did a fair amount of grunt work filling in for vacationing full timers, but he also created some original watercolors that included that gorgeous *Canadian Steam* opus with its operatic title, *On the Prairies Where the Wheat Grows and the Sun Comes Up Yellow in the East* (p. 18-19). To this day I'm astonished by the maturity a twenty-something college kid brought to this particular painting.

There was another young star in the company's art department in the 1960s: John Swatsley, now an internationally recognized watercolorist, especially in the field of wildlife art. A graduate of the Art Center College of Design in Los Angeles, he is a member of the American Watercolor Society. His association with Kalmbach's art was brief, but he made a strong impression with a slashing, muscular style that set him apart from other railroad artists. A beautiful example is his cover painting for March 1965 *Trains*, an artist's conception of the advanced "integral train" concept, unfortunately printed in black-and-white in the magazine but presented here (on p. 47) in its original color. His earth-tone ink-and-wash illustrations more than a decade later for Kalmbach's *Railroad Station Planbook* are all minor masterpieces (see them all p. 39-45).

Swatsley's work for Kalmbach was special to me, and I count myself fortunate to have had the opportunity to commission him for a *Trains* project. It came in late 1999 as we contemplated the upcoming April 2000 issue to celebrate the centennial of the train wreck at Vaughan, Mississippi, involving the legendary Casey Jones. Blessed by a terrific piece of historical journalism by the late Pete Hansen, I wanted to go all out on the cover. With a dearth of interesting photos from Casey's era, I figured we needed a cover painting, and Swatsley struck me as the perfect choice. Lucky for us, the artist was game for trying another railroad piece and agreed to do it for a fee that wouldn't bust our budget.

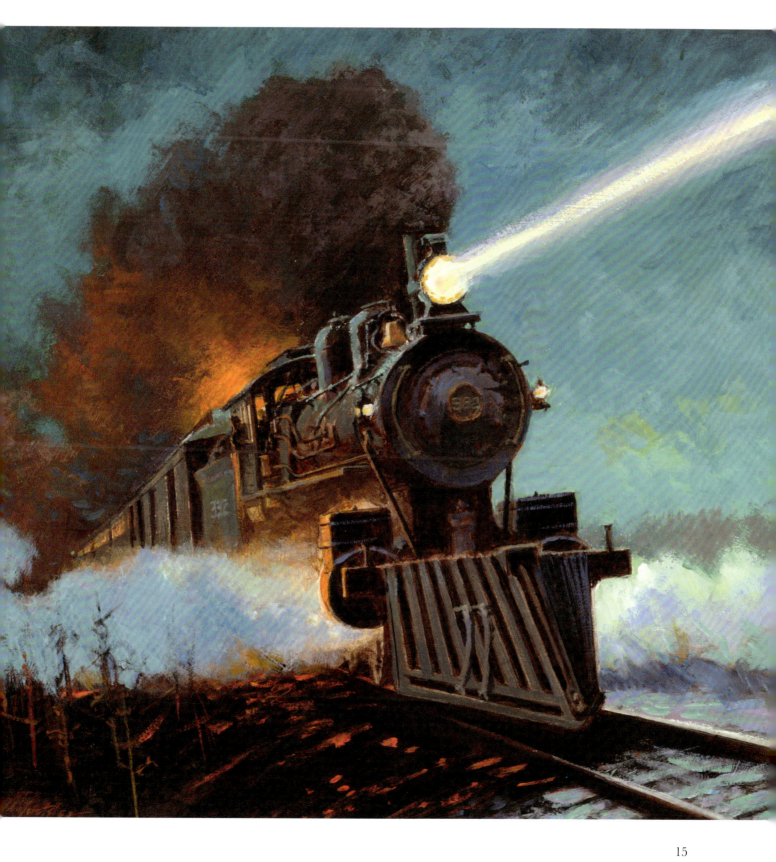

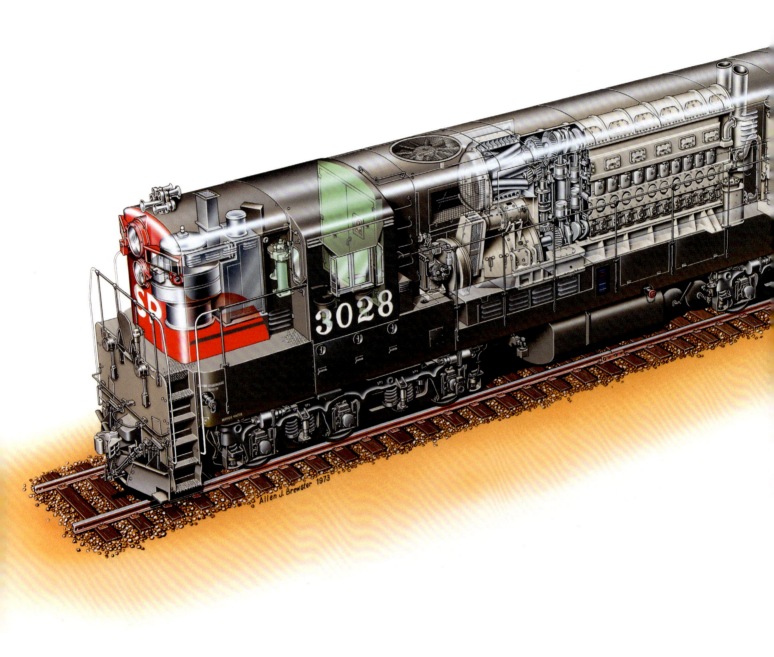

Allen J. Brewster
Southern Pacific Train Master
21x31 inches, 1973
Mixed media with airbrush color rendering
Kalmbach-037

Published in *Trains*, August 1973

The resulting effort—a vivid depiction of Casey's and Ten-Wheeler 382's last moments—made for a great cover, and we were rewarded with a surge of newsstand sales. I give Swatsley a huge share of the credit.

Other famous names grace this collection, of course, reflecting Kalmbach's ability in the early years to attract the best talent, even when the company couldn't afford it. Thus, we have three works by Howard Fogg, the dean of American railroad painters and a favorite of mid-century railroad presidents. He was also a close friend of Gil Reid; they together attended the Chicago Academy of Fine Art. Also represented in the collection: Kent Day Coes, a longtime art director for McGraw-Hill in New York and considered in the front rank of American landscape painters; Phil Belbin, a leading Australian artist, illustrator, cartoonist, and steam locomotive expert; and Richard Ward, a respected British painter of all manner of transportation, including trains, ships, and airplanes.

Finally, a word about Allen J. Brewster, a phenomenal technical illustrator who graced the Kalmbach payroll for sixteen years. Although he was not a fine artist in the strictest meaning of the term, his precise draftsmanship, his gift for deep research, and his deft touch with an airbrush resulted in two works that are among the most revered in the Kalmbach canon, both of them fantastically detailed, full-color cutaway drawings. To illustrate stories about Amtrak's purchase of used passenger railcars and a profile of Fairbanks-Morse Company's celebrated Train Master diesel, *Trains* editor David P. Morgan asked Brewster to do almost the impossible. Allen was happy to oblige.

The paintings in the Kalmbach Collection were created over a relatively short span of years, roughly 1945 to 2000, or fifty-five years, and they portray a world of railroading that, as a practical matter, mostly is gone. All the more reason to permanently celebrate their legacy. T. Bondurant "Bon" French, who chairs the Center's board of directors, spoke for the entire CRP&A community in underscoring its significance. "Not only is it a spectacular collection in its own right, but the art invokes many memories for those of us that frequented the hallowed halls of the Kalmbach offices. As the Kalmbach name will otherwise disappear, it's great that we can preserve the legacy of a ninety-year-old company with a revered name through this collection." •

Gallery

Ted Rose
On the Prairies Where the Wheat Grows and the Sun Comes Up Yellow in the East
14x19 inches, c. 1961
Watercolor on paper
Kalmbach-052

Published as the dust jacket of *Canadian Steam*, 1961, edited by David P. Morgan. The painting portrays Canadian National Extra 6030 East at Portage La Prairie, Manitoba.

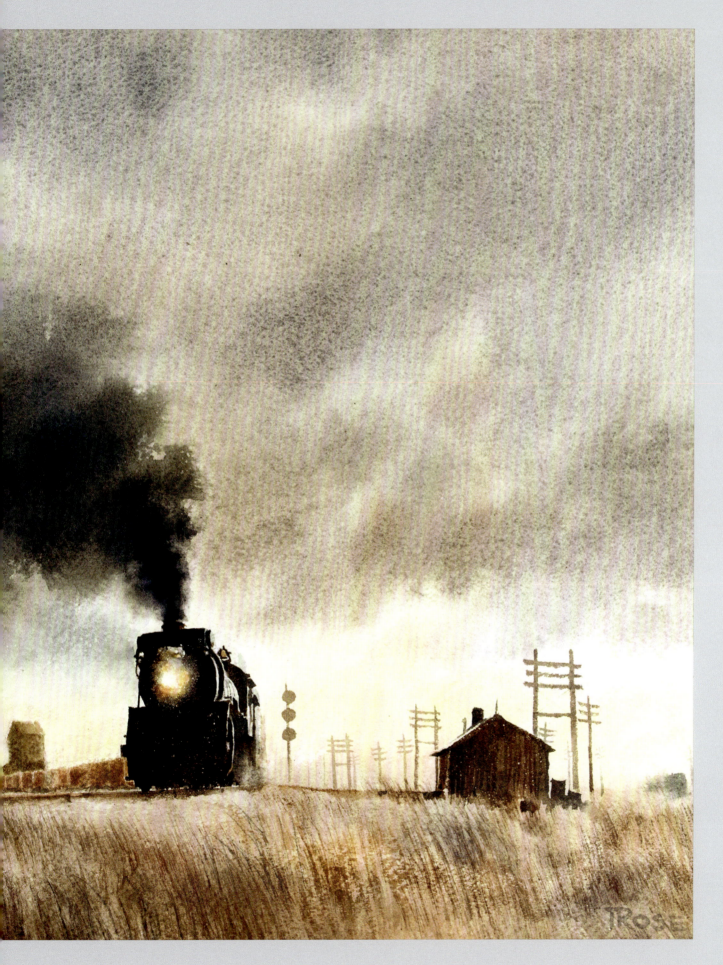

Ted Rose
Canadian Pacific 4-6-0
11x18 inches, c. 1961
Watercolor on paper
Kalmbach-016

Ted Rose was an undergraduate art student at the University of Illinois when he painted the masterpiece on the previous spread for the cover of *Canadian Steam*, part of his work of designing the book during a summer job with the Kalmbach art department in 1961. The book is a celebration of the place many American rail enthusiasts turned for a few more years of steam railroading after it had ended in most of the United States.

Rose was one of them, then as a photographer, but through his innate gift as a watercolor artist, he crafted a single image that stands for much of the allure of those final years of steam on the Canadian prairies. The painting hung prominently in the Kalmbach offices for decades, where it stopped visitors in their tracks and became a favorite muse for many staff members.

His watercolor at right, also set in the Canadian prairies during the late steam era, was never published. It may have been a preliminary study for the *Canadian Steam* cover.

Two other Rose paintings are in the Kalmbach Collection. *Only Yesterday*, his homage to longtime *Trains* editor David P. Morgan, is on the rear cover. Rose completed it in 1990 for the magazine's 50th anniversary. It shows Morgan admiring a New York Central Hudson locomotive, recalling his legendary "Steam in Indian Summer" trips from the 1950s with friend and photographer Dr. Philip R. Hastings.

The following spread pairs the other Rose painting with a Howard Fogg watercolor. Neither have been published previously, but they are both poignant examples of the allure of railroad scenes even without trains in them.

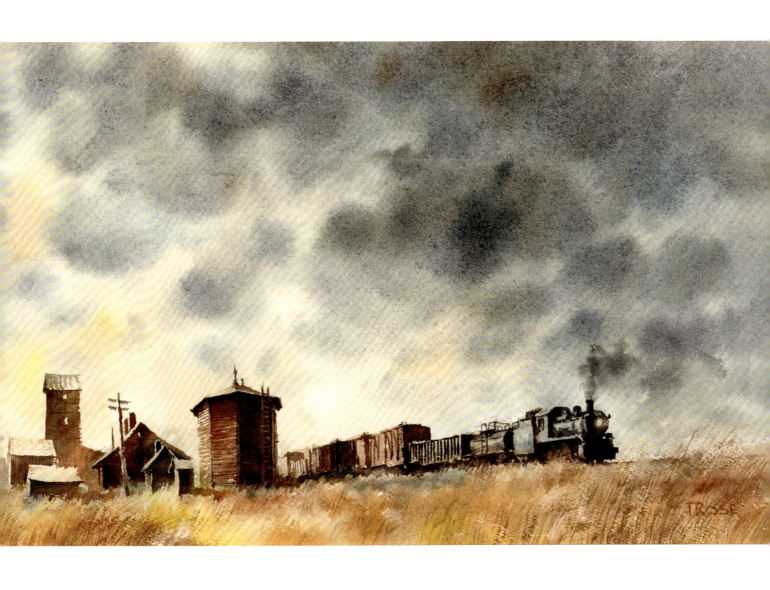

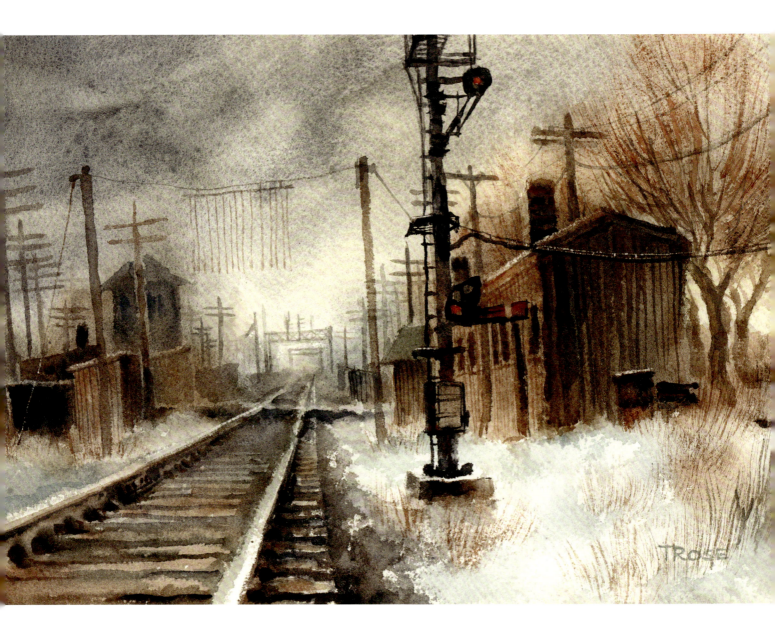

Ted Rose
Chicago & North Western Signal
11x16 inches, c. 1961
Watercolor on paper
Kalmbach-017

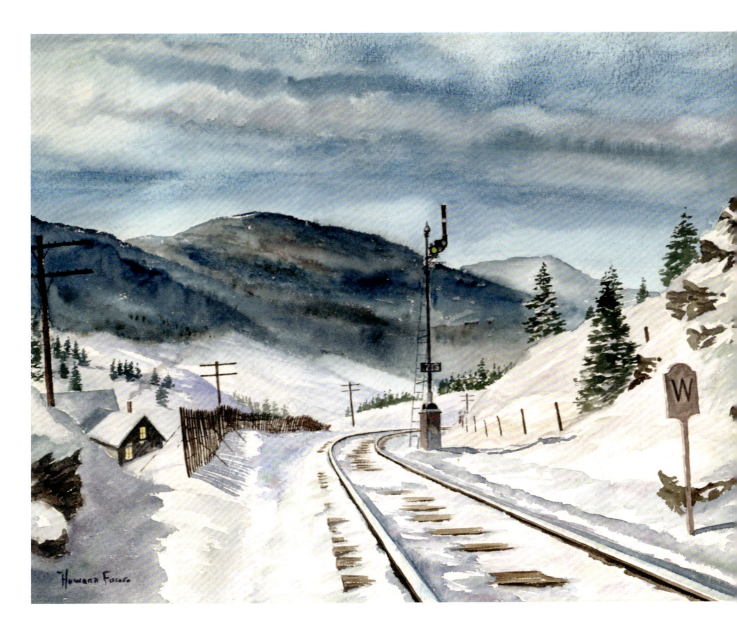

Howard Fogg
Train Tracks in Winter
14x20 inches, c. 1950
Watercolor on paper
Kalmbach-028

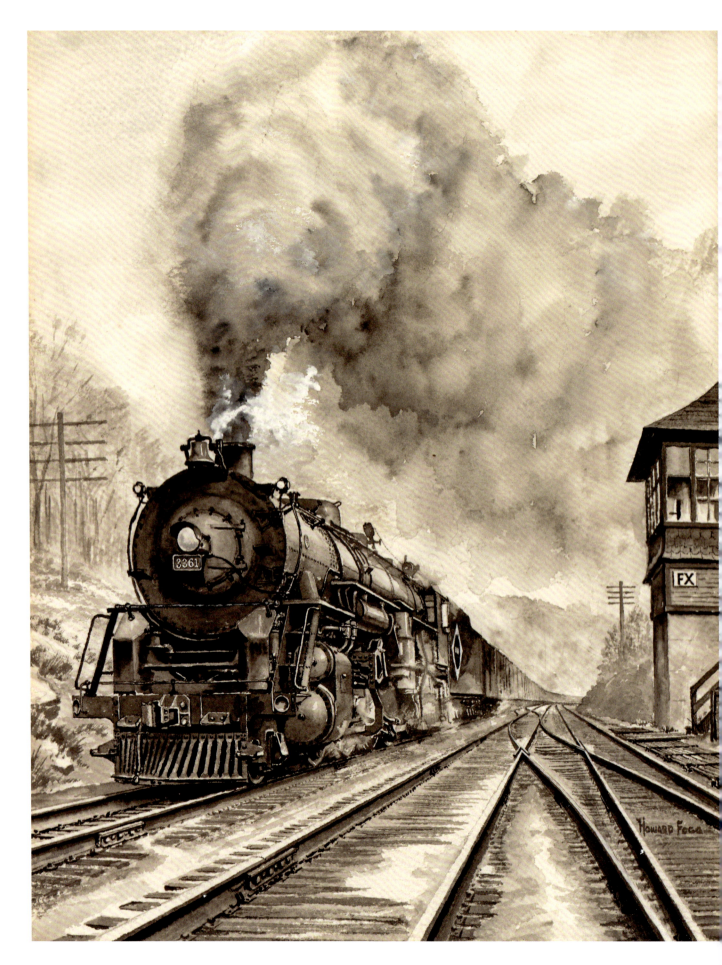

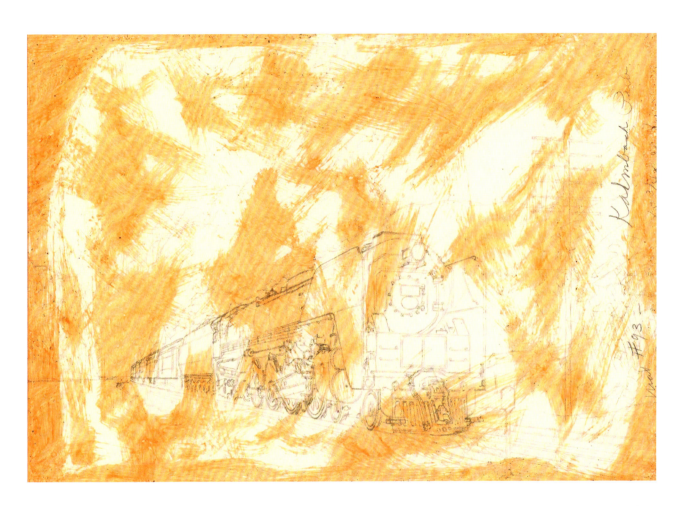

Howard Fogg
Erie Berkshire on Port Jervis Hill
13x10 inches, c. 1947
Ink wash on paper
Kalmbach-015

Published in *Trains*, February 1948

Howard Fogg's ink wash of an Erie 2-8-4 leading a freight train ran in the February 1948 *Trains*, whose cover banner proudly proclaims, "The illustrated magazine about railroads." From its first issue, art was an integral part of the publication. This piece ran with three photographs and a chart of "principal dimensions" of Erie's S-3 and S-4 locomotives.

The Kalmbach Art Collection includes another Fogg ink wash for another two-page spread about a particular locomotive type, Milwaukee Road 4-8-4s, which appears on the cover of this publication and also ran in the January 1948 *Trains*. Locomotive spreads were common in the magazine at the time, but only these two led to original art.

Unique among all paintings in the collection, this one also includes a sketch on the rear, reproduced above. The subject appears to be a New York Central 4-8-4 Niagara steam locomotive pulling a passenger train. It may have been a preliminary study by Fogg for another painting.

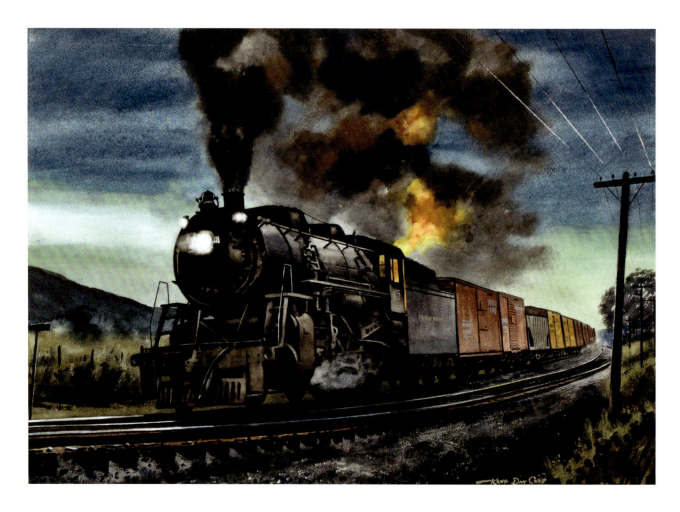

Kent Day Coes
Untitled
20x28 inches, c. 1943
Watercolor on paper
Kalmbach-039

Kent Day Coes
Westbound Freight
18x23 inches, c. 1943
Watercolor on paper
Kalmbach-040

Published in *Trains*, September 1943

Kent Day Coes submitted two original watercolors to *Trains* magazine in the early 1940s. The painting above was never published, while the one at right ran as the centerspread in the September 1943 issue. It appeared after a technical article about railroad signalling, accompanied only by its title in cursive at lower left. The magazine was not quite three years old, and the expense of full-color printing made its use rare. The effect must have been dazzling to readers.

A blurb at the bottom of the prior page introduced the artist and his wife while providing caption information. The train is a New York, Ontario & Western freight passing under the Erie's Graham Cutoff just west of Campbell Hall, New York. This was only the second full-color centerspread in the history of *Trains* magazine. The first appeared three issues earlier and also featured a painting—by Gil Reid, and sadly not part of the Kalmbach Art Collection.

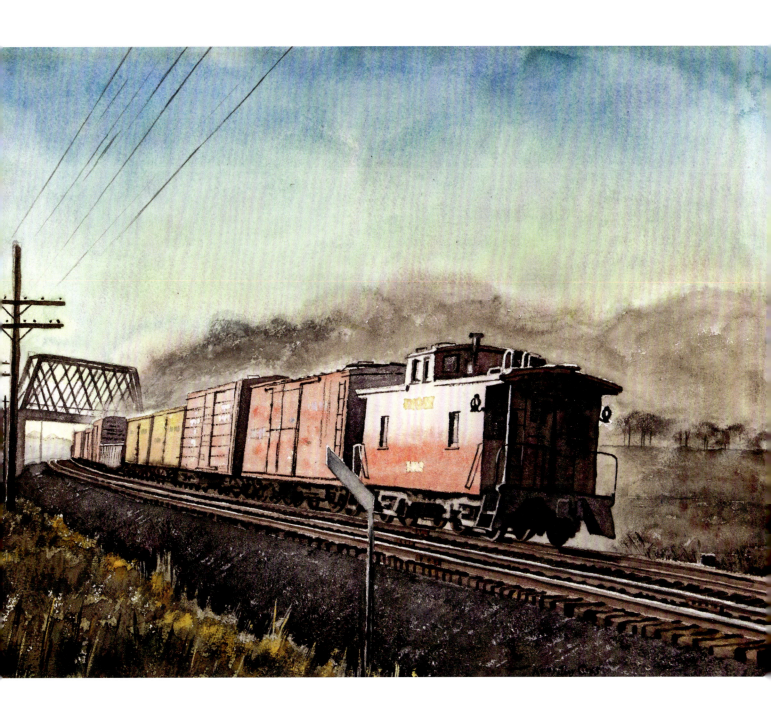

Richard Ward
Starrucca Viaduct
13x18 inches, c. 1956
Tempera on paper
Kalmbach-023

Published in *Trains*, November 1956

Erie 0-8-8-0 compound Mallet No. 2600 pushes a freight train across Starrucca Viaduct at Lanesboro, Pennsylvania, as Delaware & Hudson 4-6-0 No. 507 leads a passenger train beneath the stone-arch icon.

This was the third of three consecutive issues of *Trains* with full-color paintings as their centerspreads. Editor David P. Morgan let this work speak for itself. It did not accompany an article but appeared in the middle of the issue's Photo Section with only a five-word caption: "Starrucca Viaduct … a period painting."

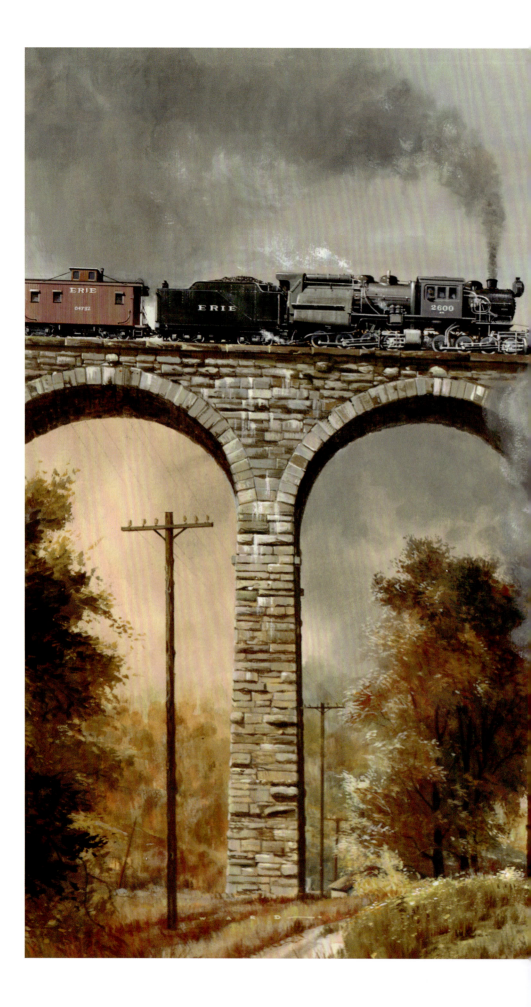

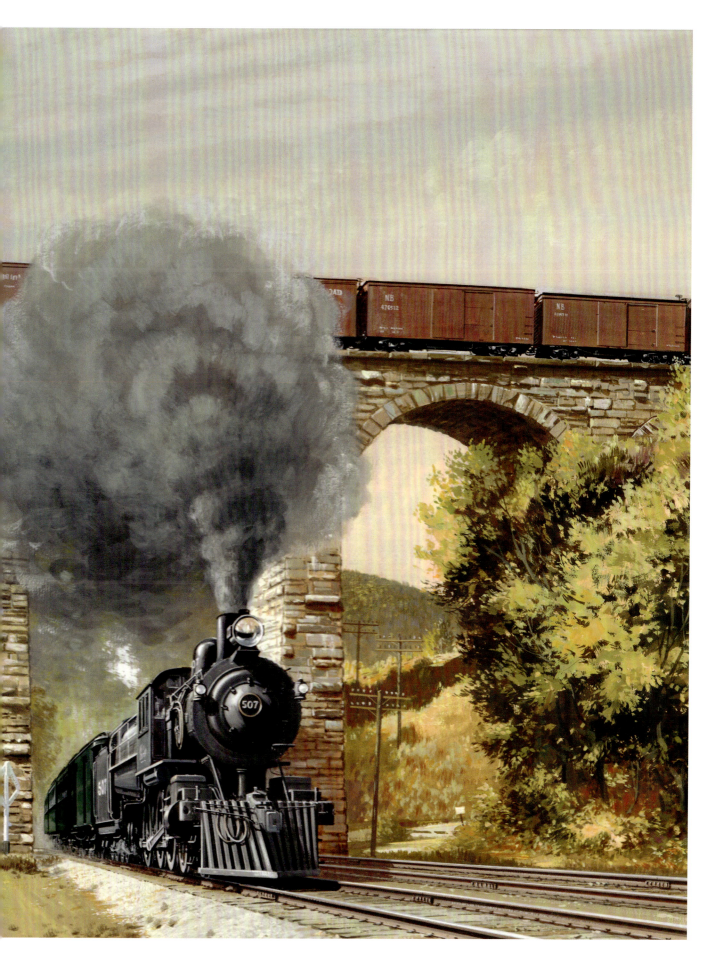

Richard Ward
Virginian Railway
16x12 inches, 1961
Tempera on paper
Kalmbach-018

Published on the dust jacket of *The Virginian Railway*, 1961, by H. Reid

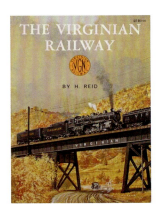

Richard Ward
General Motors Aerotrain on the Santa Fe
15x14 inches. c. 1956
Tempera on paper
Kalmbach-030

Published in *Trains*, May 1956

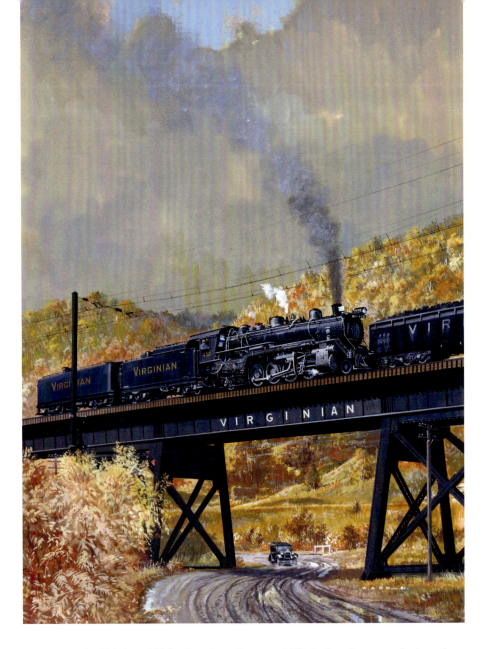

British artist Richard Ward painted several Kalmbach commissions in the 1950s and '60s, including the cover for H. Reid's book, *The Virginian Railway*. On the line's signature grade from Mullens to Clarks Gap, West Virginia, an MB-class 2-8-2 pushes a coal train over Gooney Otter Creek and State Highway 10, where a Ford Model A splashes through puddles on the unpaved road. The author supplied the artist with a photograph of his own Model A that he drove during college.

The overhead wires date the scene after the railway's electrification in 1925, as steam continued to handle passenger trains and assist with coal and other freight as needed. While the Virginian was noteworthy for its use of electric traction, Kalmbach executives may have felt an image of steam on the cover would yield more book sales.

Similar thinking may have led to Ward's juxtaposition of a General Motors' Aerotrain next to a Santa Fe 4-8-4 in the Southwest for the cover of the May 1956 *Trains*. While the image portrays optimism, the accompanying article opened with an ominous question: "Those new trains...more splash than speed?"

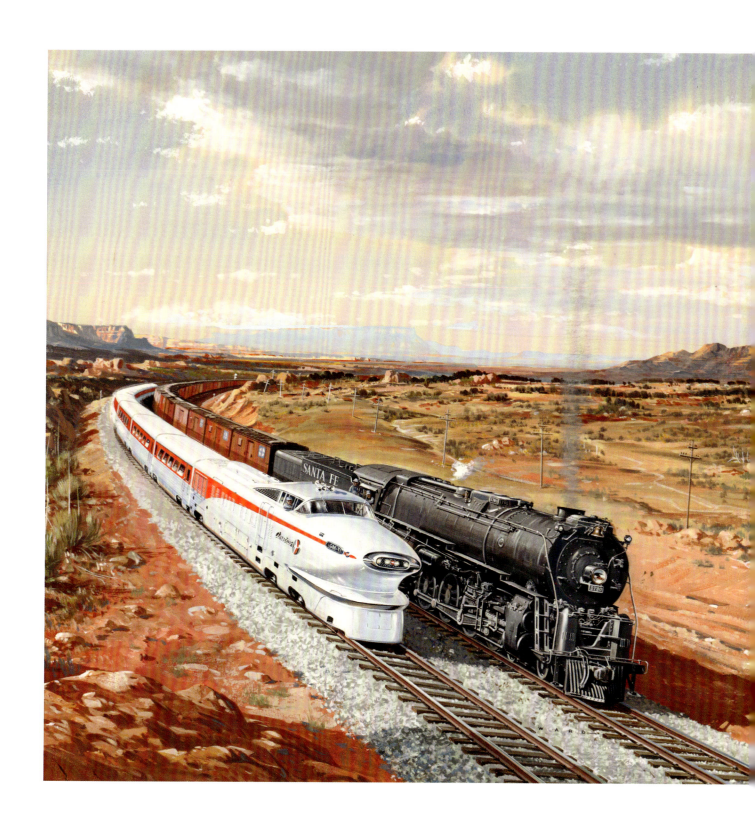

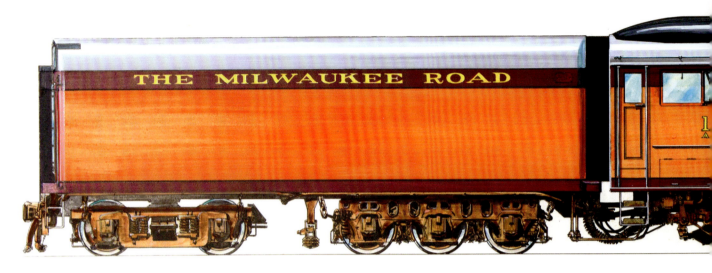

Gil Reid
Milwaukee Road Class A Atlantic No. 1
6x34 inches, undated
Watercolor on board
Kalmbach-041

Gil Reid
Untitled
10x16 inches, 1955
Watercolor on paper
Kalmbach-051

Milwaukee Road steam locomotive No. 1 is the subject of three paintings in the Kalmbach Art Collection. Gil Reid portrayed the streamlined speedster twice—dramatically leading the *Hiawatha* in his signature work *Roaring Through Rondout* that appears on p. 8-9, and at rest in the above image for use as a bookmark. The third depiction came from George Gloff: a conceptual drawing on p. 54 that imagines how the engine might have looked without its streamlining—an interesting comparison to this work.

The stardom is fitting for what was once the premier locomotive and the premier train of the hometown railroad for Kalmbach. The American Locomotive Company built the engine and its three siblings in the railroad's A class, Nos. 2-4, between May 1935 and April 1937 to the Milwaukee's specifications. Brooks Stevens, the city's renowned industrial designer, crafted their streamlined styling. They routinely hit 100 mph while pulling the *Hiawatha* trains between Chicago and St. Paul in as little as six hours and fifteen minutes.

The earlier, untitled work at right shows Reid's range as an artist. Set somewhere along the Santa Fe Railway, it relies more on impression than precision. When he painted it in 1955, Reid was still in his twenties and not yet a member of the Kalmbach staff. Through his long tenure with the company and later freelance efforts, he had a great influence on the visual identity of Kalmbach and *Trains* magazine. Nine of his watercolors are part of the collection. It also contains nine works from John Swatsley and ten from George A. Gloff, but those totals are due in part to groups of drawings and inkwashes. Reid has more paintings in the collection than any other artist.

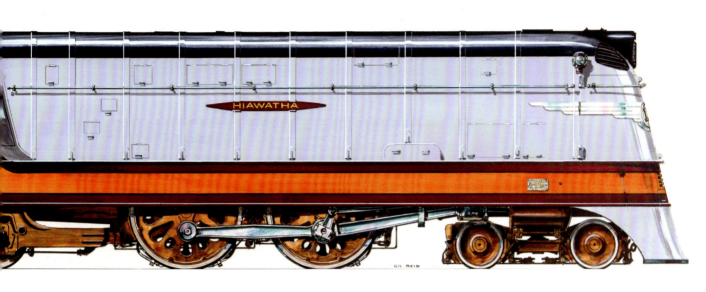
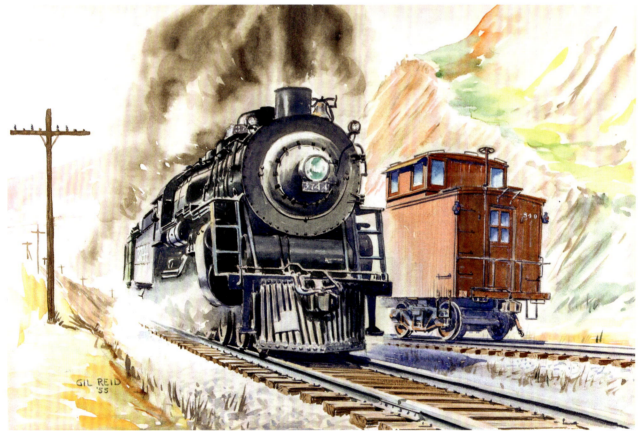

Gil Reid
On the Road
11x25 inches, c. 1963
Watercolor on paper
Kalmbach-042

Published on the dust jacket of *Apex of the Atlantics*, 1963, by Frederick Westing. A book about the zenith of a locomotive type called for a heroic image of one. Reid portrayed Pennsylvania Railroad 4-4-2 No. 737 taking a heavy passenger train over the road's New York Division at eighty miles per hour. The forward lean, trailing smoke, blurred driving wheels, and firebox glow in the cab all convey speed and drama.

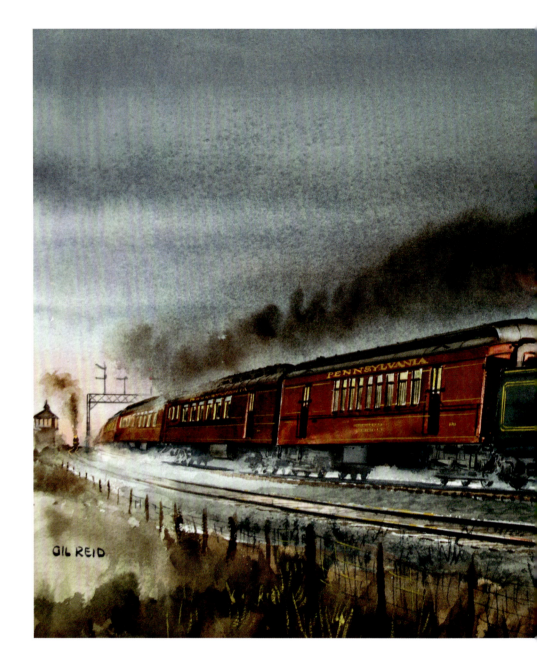

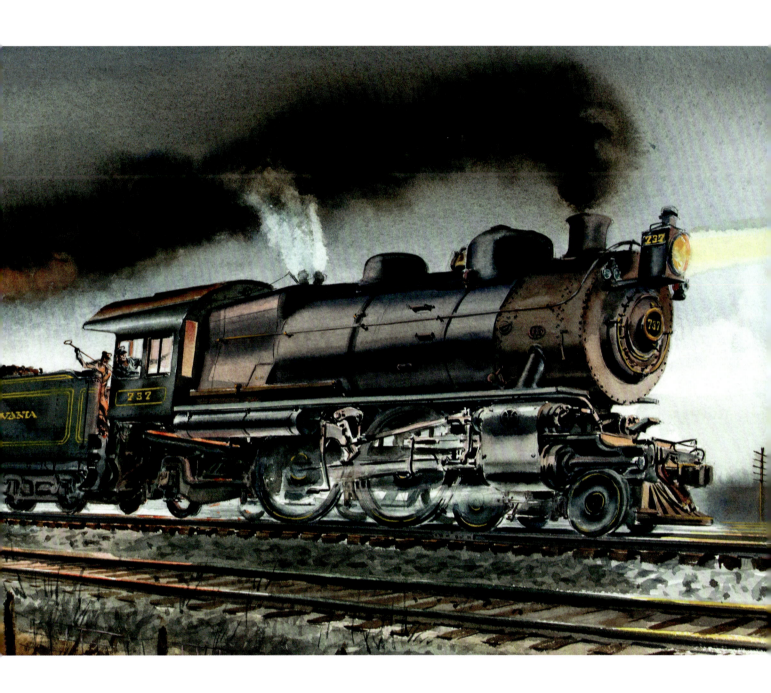

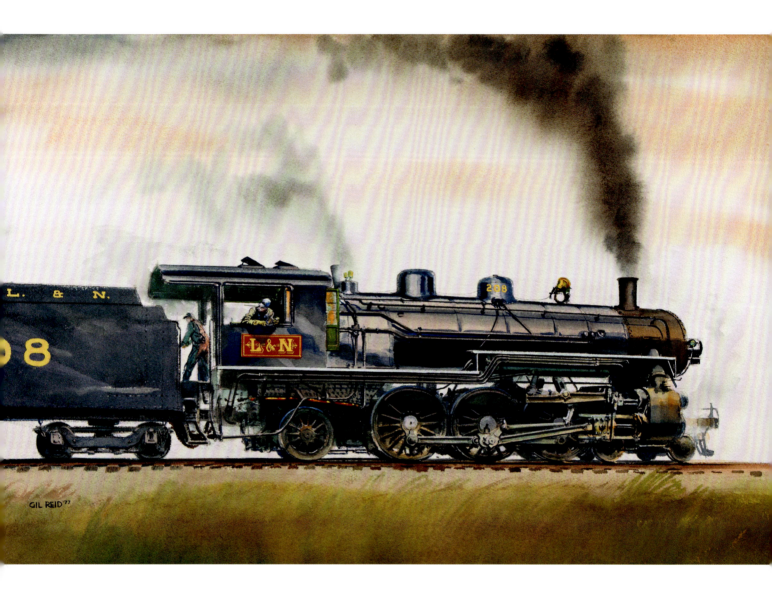

Gil Reid
Louisville & Nashville K-3 Pacific
18x26 inches, 1977
Watercolor on paper
Kalmbach-033

Published in *Trains*, November 1990, 50th anniversary issue

Just before he retired from Kalmbach in 1978, Reid painted Louisville & Nashville No. 208 as a gift for David P. Morgan, his friend and longtime *Trains* editor. Morgan, who loved the L&N, had the painting matted and framed, and he hung it in his office. After he retired in 1987, the painting stayed, and it moved with Kalmbach to new offices.

The work remained unpublished until 1990. For that year's 50th anniversary issue in November, Morgan's successor, J. David Ingles, asked several regular contributors to share their reflections on the magazine, the industry it covers, and some of the people involved. Reid submitted this work along with a few paragraphs about the painting and its recipient. They open one of the three main sections of the semicentennial issue, fittingly called "Perspectives."

Gil Reid
Northern Pacific Z-5 Steam Locomotive
20x15 inches, c. 1981
Watercolor on paper
Kalmbach-053

Published on the cover of *Trains*, March 1982, to introduce a two-part article about Northern Pacific's Z-5 2-8-8-4 Yellowstone-type steam locomotives. The banner states, "Until Big Boy … world's largest locomotive." Reid conveyed their muscular bulk with a head-on view emphasizing the massive boiler and all-business face.

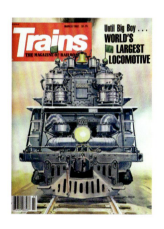

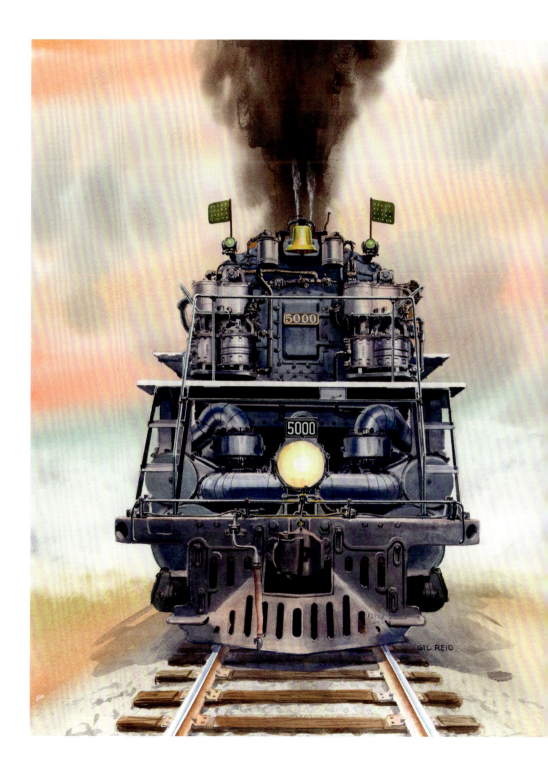

37

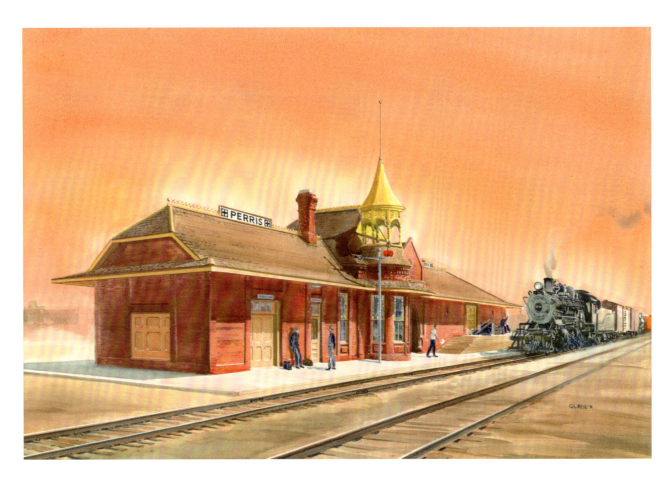

Gil Reid
Santa Fe station at Perris, California
15x22 inches, 1976
Watercolor on paper
Kalmbach-027

Published on the cover of *Railroad Station Planbook*, 1977, by Harold Edmonson

Railroad Station Planbook, an unassuming softcover by Harold Edmonson published in 1977, is responsible for eight pieces in the Kalmbach Art Collection—nearly one-sixth of the total.

Gil Reid painted the cover, which features Santa Fe's 1892 depot in Perris, California, a branchline junction about seventy miles east of Los Angeles. Beneath a sunrise sky, a 2-8-0 steams in with a local freight from the south. The brick structure with its conical turret and other Queen Anne styling is the kind of classical and charming station that could appeal to readers all over the country. The depot still stands and is home to the Perris Valley Historical Museum.

Inside, in addition to text, photographs, and technical drawings, are seven inkwashes by John Swatsley, then Kalmbach's art director. Each one is an expert blending of precision and impression, omitting many details while still conveying the intrigue of railroad stations with great accuracy. While the rest of the book offers the kinds of information that model railroaders could use to build their own miniature stations, these works served to excite their imaginations.

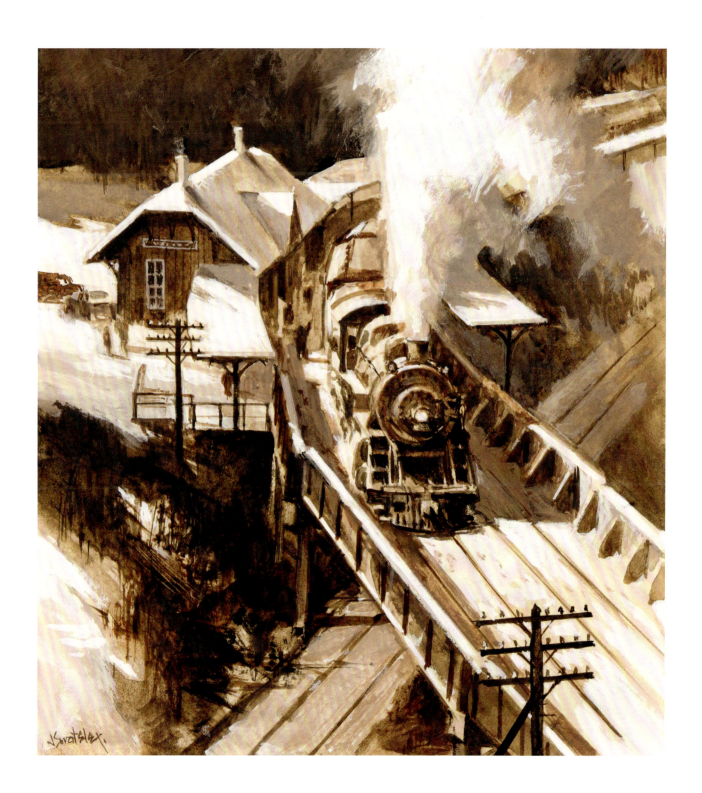

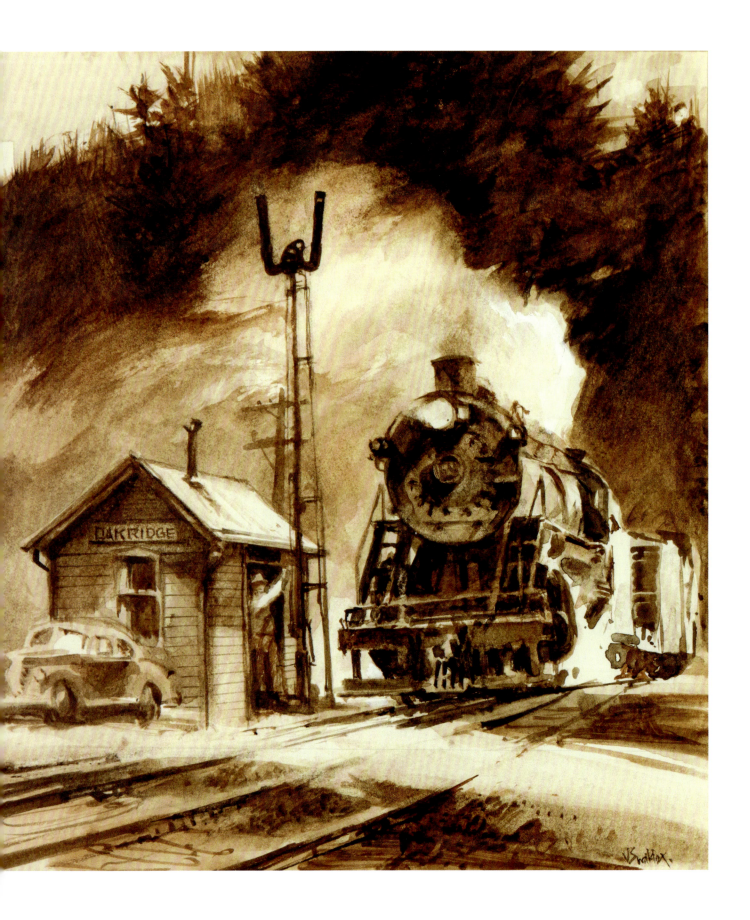

John Swatsley
Untitled works for Railroad Station Planbook
9x8 and 6x12 inches
Ink washes on paper
Kalmbach-009, 045, 046, 047, 048, 049, and 050

Published in *Railroad Station Planbook*, 1977, by Harold Edmonson

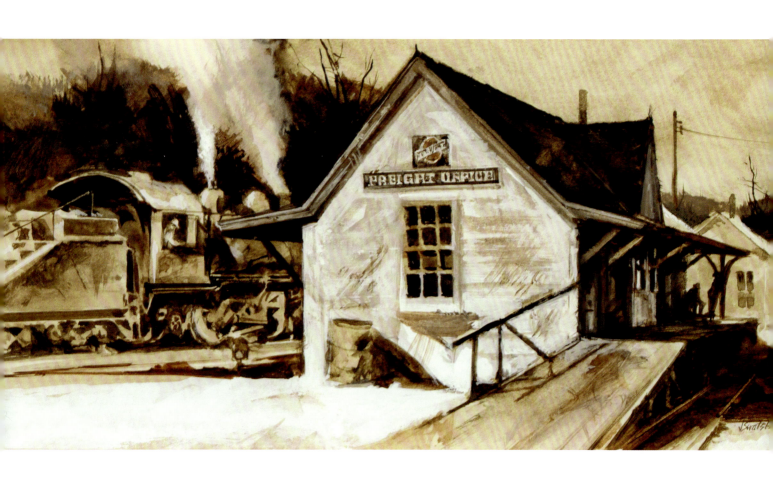

John Swatsley
Integral Train
17x12 inches, c. 1965
Acrylic on board
Kalmbach-020

Published in *Trains*,
March 1965

The bold notion of the "integral train"—proposed by John Kneiling, an engineer at the Theodore J. Kauffeld consulting firm—needed an equally bold cover for the March 1965 *Trains*. Kalmbach artist John Swatsley rendered a futuristic and moody impression with deep blues, purples, and reds. Those colors were lost in the era's standard cover treatment, though; the issue appeared near the middle of a nine-year span when the magazine budget could afford only black-and-white imagery with a red accent on its covers.

Still, the March 1965 *Trains* is northworthy as the first to feature a cover painting since May 1956. With its journalistic roots, *Trains* has used far more photographs than paintings, but no photographs existed of this concept. Inside, three Swatsley sketches accompanied David P. Morgan's words about the integral train in his "News and Editorial Comment." They ran under a provocative headline: "A train for survival."

Both the magazine and the rail industry faced headwinds in the 1960s. Competition ranging from cars and trucks to airlines to nuclear power (with no need for coal delivery) threatened railroading. The end of the steam era in the 1950s left *Trains* without its most iconic subject.

In both cases, survival demanded adaptation. While the integral train never left the drawing board, the railroads adopted many of its underlying concepts—higher capacity freight cars; much wider use of single-commodity "unit" trains; and distributed power technology with locomotives at the front, middle and rear of ever-longer trains. At the magazine, Morgan helped lead *Trains* through a successful transition to a new identity, albeit one that would rely even less on original artwork. Just look at how many of the paintings in the Kalmbach Art Collection feature steam locomotives as their primary subjects.

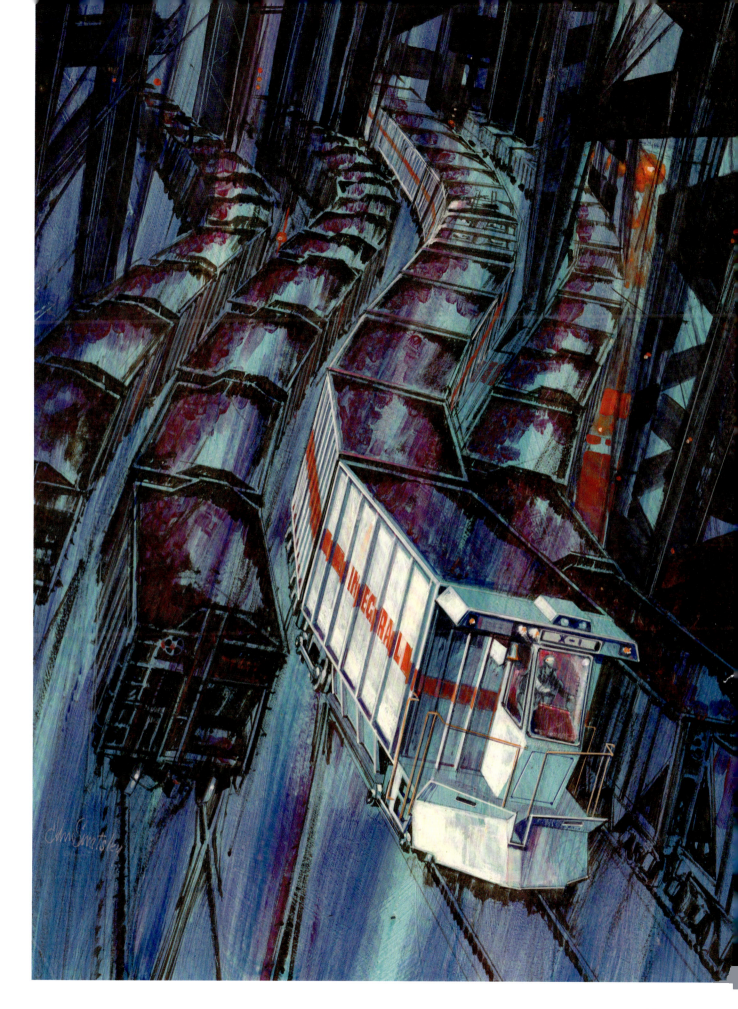

George A. Gloff
Southern Pacific Articulateds Meet in the California Desert
16x26 inches, c. 1956
Tempera on paper
Kalmbach-035

Published in *Trains*, September 1956, the first of three consecutive issues with paintings as full-color centerspreads. A cover blurb in a bright yellow box promoted this one.

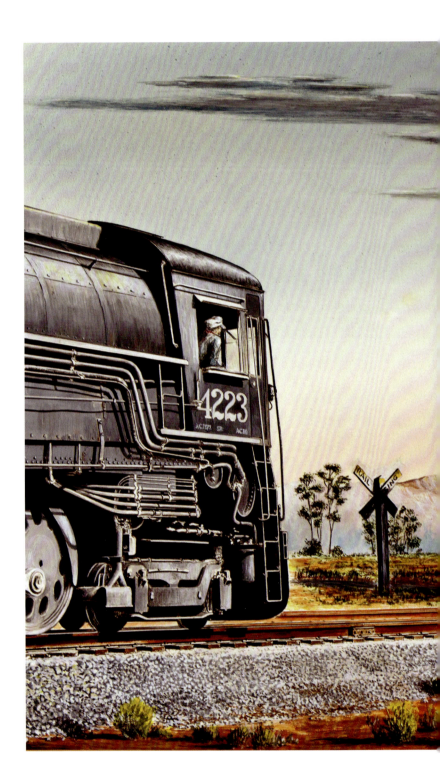

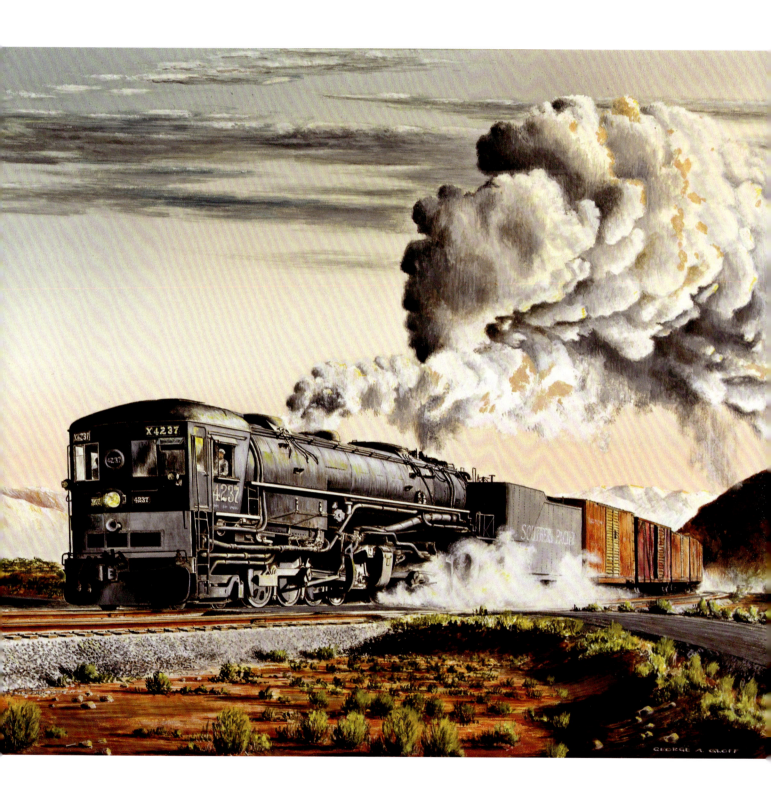

George A. Gloff
Up the Ladder
21x25 inches, c. 1962
Watercolor on paper
Kalmbach-056

Published on the dust jacket for *The Giant's Ladder* by Harold A. Boner

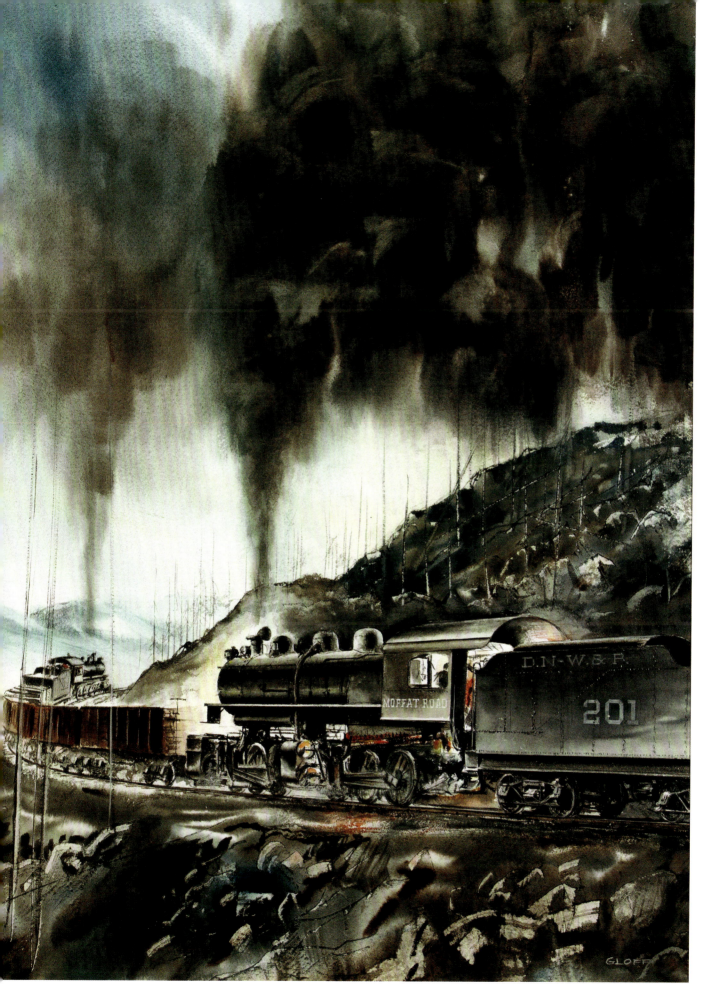

George A. Gloff
*Rio Grande Revisited
#1 and #2*
22x16 inches, c. 1965
Mixed media on paper
Kalmbach-026 and 31

Published in *Trains*, April 1965, for David P. Morgan's story "Rio Grande Revisited" about the Denver & Rio Grande Western Railroad.

Rendered with dreamlike qualities, these pieces paired perfectly with Morgan's prose—from his introduction of the Rio Grande as the "wide-awake dream" of General William Jackson Palmer, to his look ahead at what the railroad's future might hold. Morgan commissioned three works by Gloff for the piece, but only these two are part of the Kalmbach Art Collection. The third depicts an interior shop scene. The work at left is also noteworthy as the only piece in the collection to portray a second-generation diesel-electric locomotive.

George A. Gloff
Artwork for "The locomotives we saw but never saw"
8x14 inches, 1984
Pencil on paper
Kalmbach-007, 08, 10, 12

Published in *Trains*,
December 1984

Art director George A. Gloff teamed up with editor David P. Morgan for an unusual article in *Trains'* last issue of 1984. "The locomotives we saw but never saw" presents Morgan's ruminations and Gloff's renderings of what seven streamlined steam locomotives might have looked liked…had they never been streamlined. As a further curiosity, Gloff laid out the eight-page story in landscape format, forcing readers to turn the magazine ninety degrees.

Subjects pictured here are a Milwaukee Road 4-4-2, a North Western 4-6-4, Pennsylvania's 6-4-4-6, and Canadian Pacific's 4-4-4. Also featured: a Milwaukee 4-6-4, Pennsy's 4-4-4-4, and a New Haven 4-6-4.

On one hand quirky and esoteric, the article also touches on a much deeper power: *Trains'* ability to stir its readers imaginations. Morgan was never better than when describing locomotives' personalities and pecularities, while art has a singular ability to bring imagined concepts to life. A mystery remains: Only four of Gloff's seven drawings for the story became part of the Kalmbach Art Collection; the others' whereabouts are unknown.

55

George A. Gloff
Manhattan Transfer
14x24 inches, c. 1956
Tempera on paper
Kalmbach-034

Published in *Trains*, October 1956

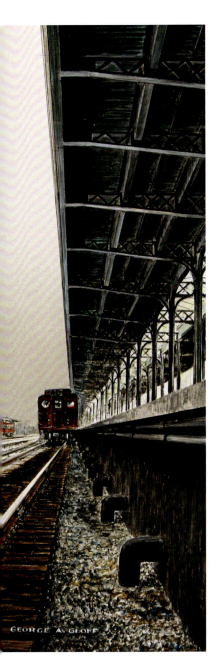

Allen J. Brewster
Streamlined Passenger Car, Cutaway View
12x25 inches, 1974
Mixed media with airbrush color rendering
Kalmbach-036

Published in *Trains*, January 1975

Cover story of the October 1956 *Trains* was "The engine that made Penn Station possible," an all-caps proclamation on a red banner against a bright yellow background. The subject was Pennsylvania Railroad's boxcab electric DD1, about which author Frederick Westing wrote: "Smile not at the DD1's flapping side rods. She conquered a river for a railroad. Besides, Pennsy had its reasons when it borrowed a steam-engine wheel arrangement, rods and all, to build a juice jack."

To illustrate the article along with several black-and-white photographs, *Trains* turned to corporate art director George Gloff for a painting to run in the centerspread. He set his scene at Manhattan Transfer, the station just east of Newark, New Jersey, where Pennsy passenger trains traded K4 steam power for the distinctive DD1s.

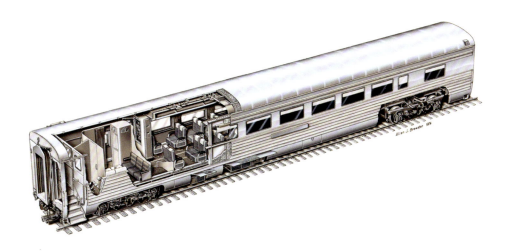

While artists' renderings of railroad equipment have appeared more frequently in Kalmbach's *Model Railroader* magazine, they sometimes show up in *Trains*. The January 1975 issue featured Allen J. Brewster's cutaway view of a streamlined passenger car across two pages (in black-and-white) with the title "A car inspector's check list" and a detailed listing of sixty-seven items.

They were part of an eleven-page article by Michael R. Weinman, "All that glitters is not stainless steel: A pro's guide to used and new passenger cars." It was a practical story, especially during the early days of Amtrak when used passenger equipment was widely available. The article also stands as evidence that many rail industry and museum professionals read *Trains* in addition to enthusiasts—and that railroad art can serve their needs, too.

Allen J. Brewster
Electro-Motive E7 for Train of Tomorrow
14x11 inches, 1977
Tempera on board
Kalmbach-043

Published in *Trains*, January 1979, for a cover story about the E7 locomotive and based on a photograph by C.P. Fox.

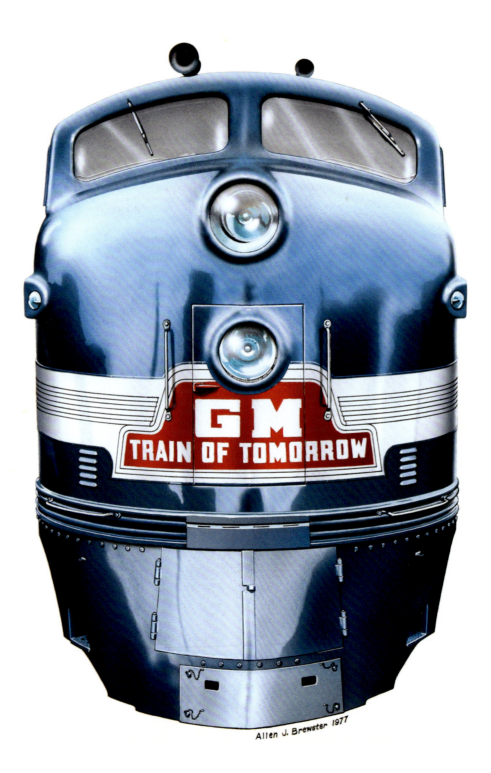

Olindo Giacomini
BLW Locomotive
14x11 inches, c. 1984
Tempera on board
Kalmbach-013

Published on the cover of *Diesels from Eddystone: The Story of Baldwin Diesel Locomotives*, 1984, by Gary W. Dolzall and Stephen F. Dolzall.

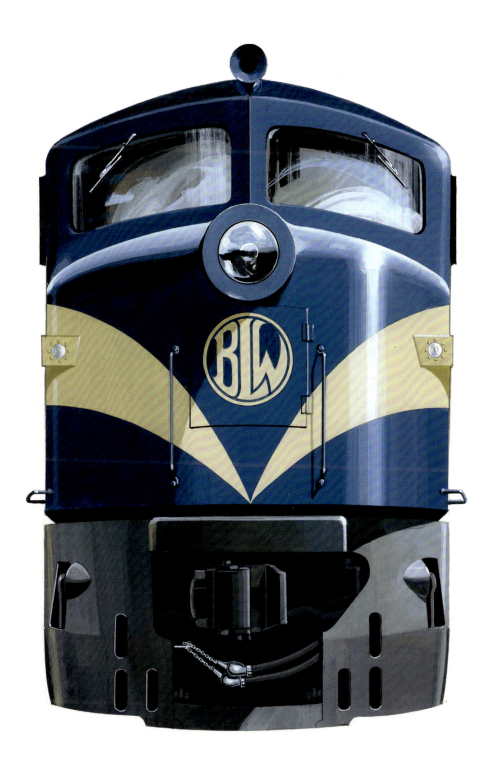

Marshall P. McMahon
Namekagon
24x20 inches, c. 1984
Acrylic on canvas
Kalmbach-054

Published in *Trains*,
August 1984

Phil Belbin
Santa Fe's Blue Goose
16x12 inches, c. 1985
Acrylic on paper
Kalmbach-019

Published in *Trains*,
June 1985

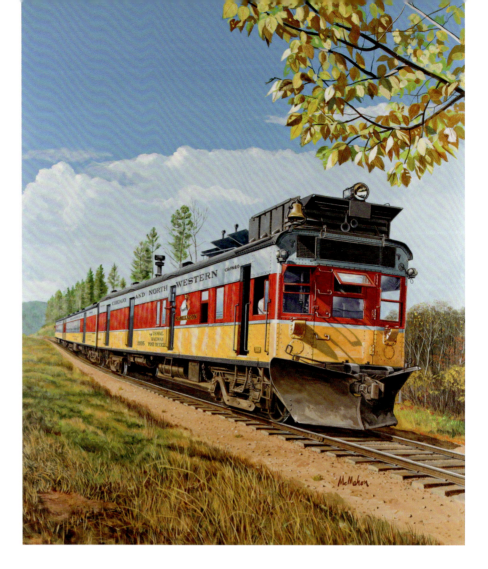

The *Namekagon* was a colorful but short-lived passenger train of a Chicago & North Western subsidiary—the Omaha Road—that connected several rural communities in northwestern Wisconsin with the Twin Cities. It entered service in early 1939 with a gas-electric "doodlebug" (a self-propelled car) for power instead of a typical steam locomotive. Its livery foreshadowed the North Western's fleet of streamlined passenger trains, called the *400s*, which debuted a few months later and became far better known.

While *Trains'* scope was national from its first issue, the magazine's staff took pride in their Wisconsin roots with occasional favor to local stories. The *Namekagon* was more than that, as it represented many railroads' ultimately doomed efforts to provide better passenger service to their less populous territories. With scant color photography available for this vibrant subject, *Trains* turned to Marshall McMahon for cover art.

The "Blue Goose," the only streamlined steam locomotive of the mighty Santa Fe Railway, demanded a cover image as distinctive as it was. *Trains* found just that with Phil Belbin's dramatically canted painting of the 4-6-4 racing between semaphore signals in a Kansas rainstorm. The artwork introduced a ten-page story by Santa Fe railroader Lloyd E. Stagner, "Blue Goose and Kin."

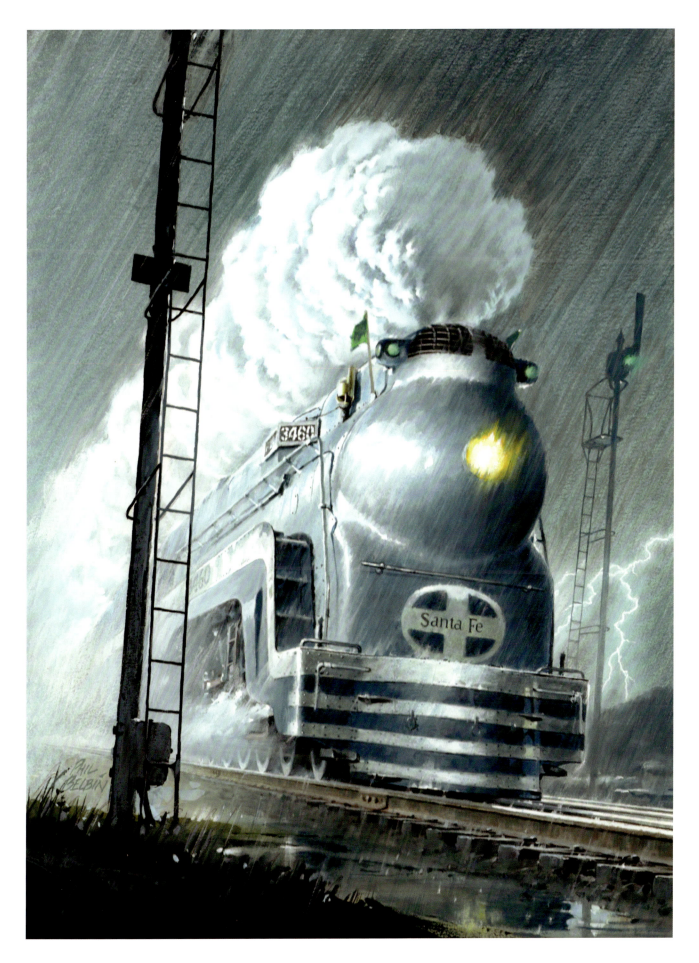

Chuck Boie
Electroliner
22x17 inches, c. 1982
Acrylic on paper
Kalmbach-004

Published in *Trains*,
October 1982

Departing for Chicago just a few blocks from Kalmbach's long-standing Milwaukee offices at 1027 North 7th Street, the *Electroliner* passenger trains held a special meaning for many of the publishing company's staff members. "They were like presents left under a Christmas tree," wrote David P. Morgan in his editorial for the October 1982 *Trains*, which kicked off a two-part article "with uncommon pride" about the colorful Chicago North Shore & Milwaukee streamliners.

Wisconsin artist Chuck Boie, who had grown up near the Milwaukee Road and Chicago & North Western tracks in the Milwaukee suburb of West Allis, prepared the issue's cover art. He based his painting on a color slide by Fred Stone. After making a pencil sketch, Boie used acrylics to paint the image, which he favors for their vibrancy and how quickly they dry.

Compared to most of the other artists with work in the Kalmbach Collection, Boie was initially something of a mystery. Lisa Hardy, the CRP&A's program administrator, took on the task of finding more about him. While combing through thousands of Google search results, she found a Milwaukee-based commercial art and advertising firm from the 1980s called The Art Factory, co-founded by Chuck Boie and Tom Nachreiner. The latter's name was so unusual that she quickly located him—teaching art classes in Fish Creek, Wisconsin. A call to the school resulted in contact information for Boie, who still lives in the Milwaukee area.

Hardy arranged a home visit with Chuck and Luann, his wife of more than forty years. While Boie is quiet by nature, Hardy said, "He would come alive with subtle excitement to talk about his art. He truly still loves transportation, and his art of trains, buses, and planes is remarkable. In fact, his basement is filled with many of his artworks and reference models." He won a prestigious gold medal from the Society of Illustrators in New York City in 1982 for his painting *Greyhound Bus*, which Hardy calls "the best example of precision hand lettering I have ever seen."

She came away feeling both impressed and deeply touched. "Chuck only ever wanted his work to be celebrated. He always tried to hide his signature within his work. He said it should be about the work, not him."

Chuck Boie
Rio Grande Southern
22x20 inches, c. 1983
Acrylic on paper
Kalmbach-038

Published on the cover of *18 Tailor-Made Model Railroad Track Plans*, 1983, by John Armstrong.

While most of the Kalmbach Art Collection portrays full-scale or "prototype" railroading, a few pieces depict smaller trains. Albert C. Kalmbach started his company in 1934 with *Model Railroader* magazine, which regularly employed the art department to render plans, designs, and concepts. Much of that work might be considered commercial illustration, but Chuck Boie's painting for the cover of the how-to book *18 Tailor-Made Model Railroad Track Plans* is an artful exception.

John Armstrong (1920–2004) was a visionary model railroader and popular author. Books about track planning spark imagination, and Boie gave life to Armstrong's concept of an elaborate "walk-around" model railroad based on a narrow-gauge scene: Placerville, Colorado, on the legendary Rio Grande Southern.

Boie's narrow-gauge painting and the Lionel artwork by Robert M. Sherman on the following pages represent a rich tradition of original art created to serve the company's hobby titles *Model Railroader* and *Classic Toy Trains*. In fact, over the decades the sheer output for those magazines in the form of track plans, mechanical diagrams, and detailed car and locomotive drawings eclipsed the work created to depict prototype railroading. At Kalmbach, the art staff was expected to be proficient in both spheres.

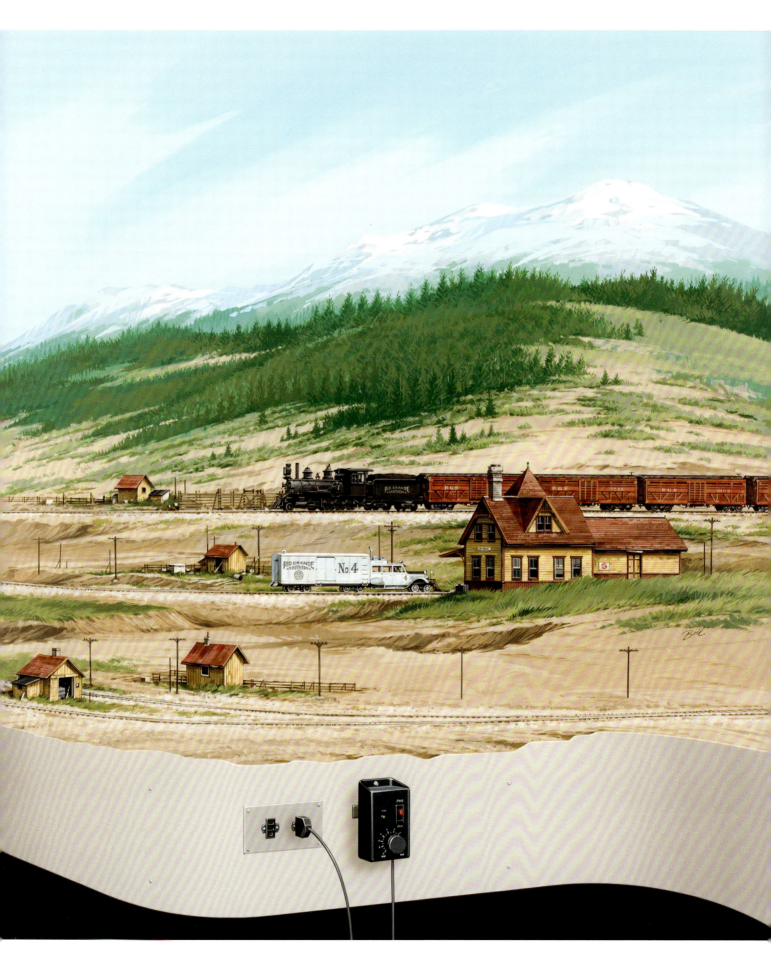

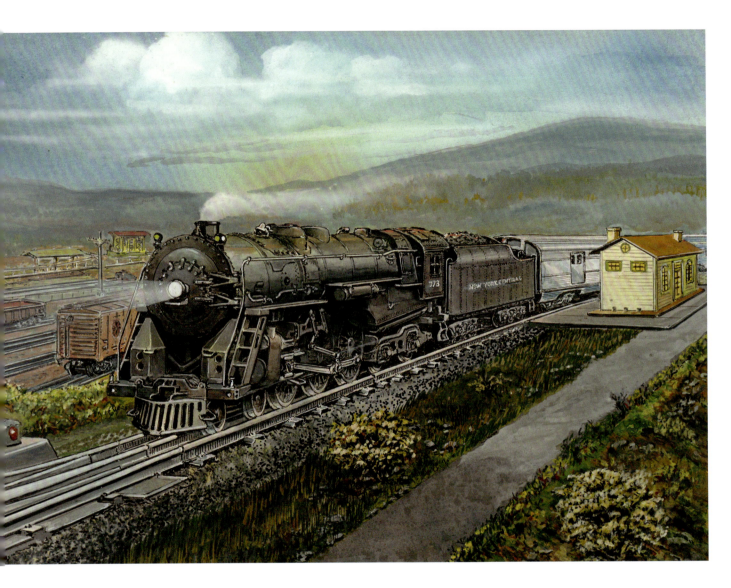

Robert M. Sherman
New York Central 773
14x18 inches, c. 1990
Acrylic and ink on paper
Kalmbach-005

Robert M. Sherman
Santa Fe 2343
13x17 inches, c. 1990
Acrylic and ink on paper
Kalmbach-022

Published in *Classic Toy Trains*, September 2017

Classic Toy Trains joined the magazine line-up in 1987, catering to collectors and operators of O- and S-gauge toy trains, distinctly different from scale model railroading. A few years later, editors of the new publication commissioned Robert M. Sherman, once an illustrator for the Lionel Corporation, to make three paintings. They eventually used two of them for covers, both with blurbs promoting stories about the artist.

Studio photography has dominated the pages of *Classic Toy Trains*; that Sherman garnered not one but two cover stories is a great testament to his work, its impact, and the legacy of the Lionel catalogs he illustrated. As editor Roger Carp wrote in 2017, "Robert Sherman drew our dreams."

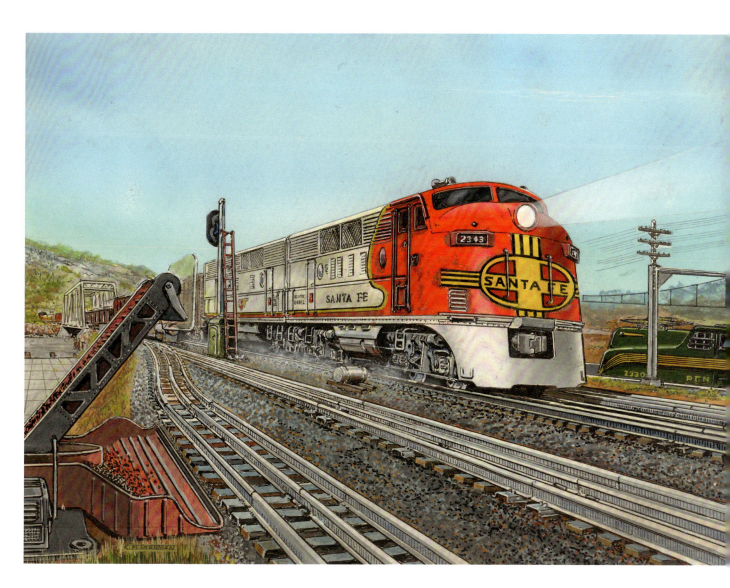

Robert M. Sherman
Pennsylvania 2330
10x12 inches, c. 1990
Acrylic and ink on paper
Kalmbach-011

Published both on the cover and as a foldout in the September 1992 issue of *Classic Toy Trains*, and later released as an exclusive limited-edition print. The issue features an interview with Sherman by Bill Curtis.

The collection also includes these preliminary drawings on notebook paper. The main subject is Lionel's version of the Pennsylvania Railroad's legendary GG1 electric, with a "Lionelville" depot in the background.

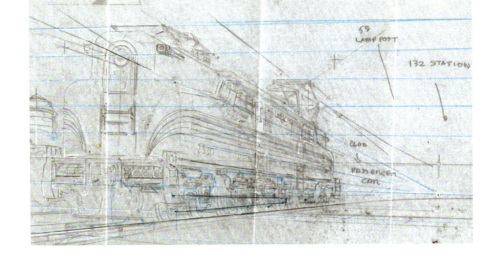

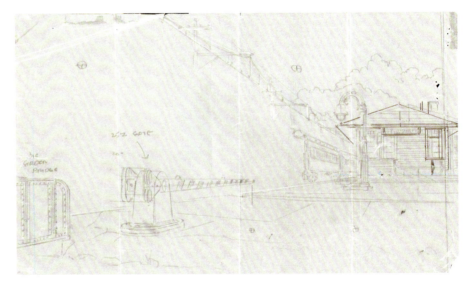

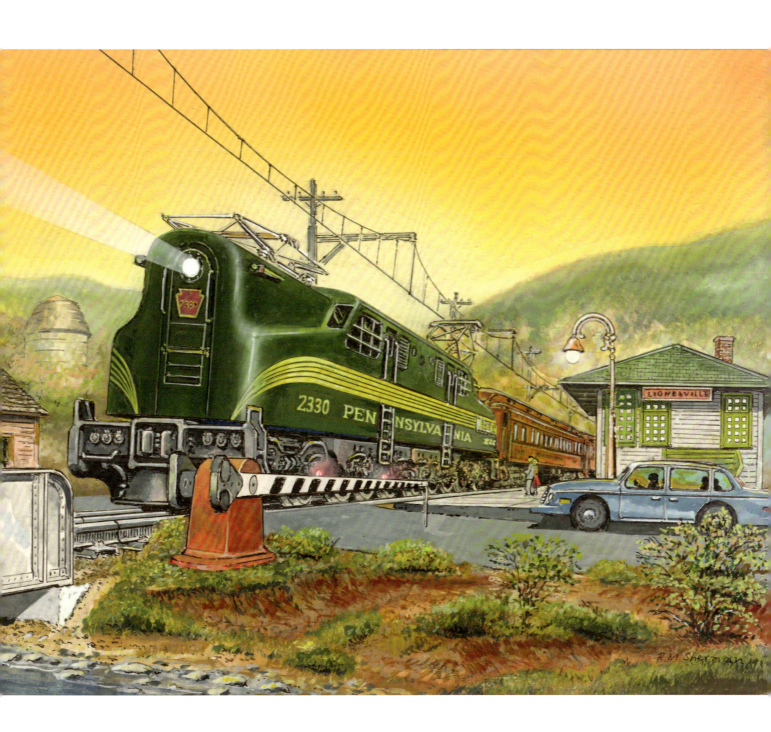

Lawrence Luser
The Mohawk That Refused to Abdicate
16x15 inches, c. 1975
Ink on paper
Kalmbach-044

Published on the dust jacket of *The Mohawk that Refused to Abdicate and other tales*, 1975, by David P. Morgan and featuring photography by Philip R. Hastings.

A cult classic among railroad book aficionados, *The Mohawk That Refused to Abdicate and other tales* is an illustrated collection of stories about tracking down some of the last steam locomotives in the United States and Canada during the 1950s. It is also much more: a showcase of some of the finest writing and photography from two of railroading's greatest practitioners, David P. Morgan and Dr. Philip R. Hastings.

The foil cover is both a product of the 1970s disco era and the insight of Larry Luser, the Kalmbach designer tasked with the book's layout. Luser already had several years under his belt in Kalmbach's Art Department when the *Mohawk* project landed on his desk, but of all the employees on that very traditional staff, he was probably the least "buttoned down"—as evidenced by his participation in Milwaukee's fertile design scene (he was active in the Milwaukee Advertising Club) and his hobby of racing sports cars in amateur events at the Road America course at Elkhart Lake, Wisconsin.

While railroad book covers of the time typically used color paintings, Luser felt that only a monochromatic cover would do for a work featuring so much outstanding black-and-white photography. He based his pen-and-ink drawing on a Hastings photograph from the *Mohawk* book's titular tale: New York Central 4-8-2 No. 3005 bearing down on Shelby, Ohio, "with all the implications of destiny of the Book of Revelations." •

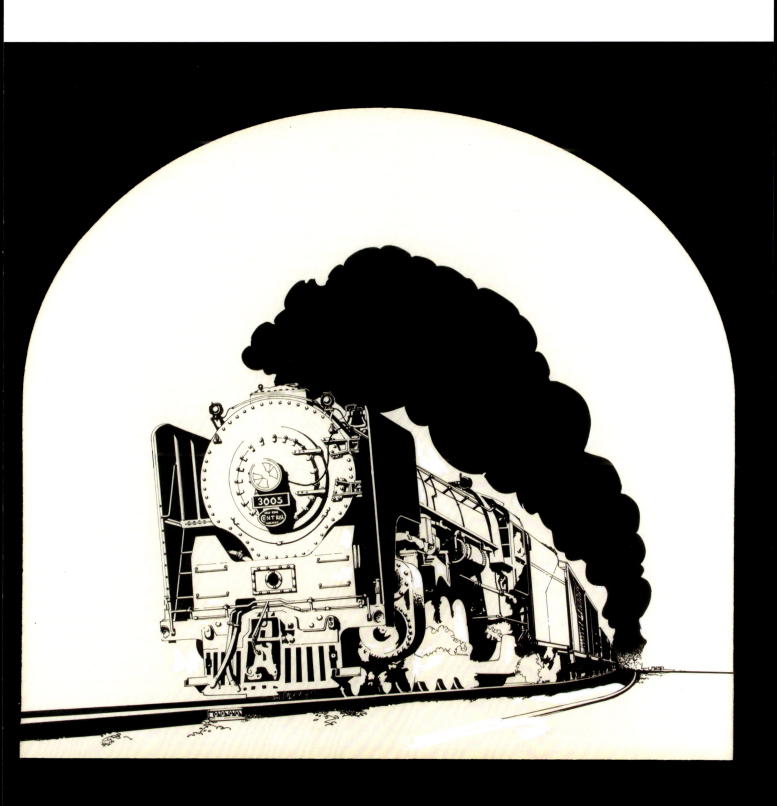

About the Artists

Phil Belbin, 1925–1993

Belbin was a prolific artist in his native Australia. He began drawing comics at age eleven and interned at Sydney's *The Sun* newspaper in 1942. Following service in the Royal Air Force during World War II, he went to work for K.G. Murray Publishing Company, where he created cartoons, comic strips, and artwork for thirty years. He continued doing freelance work and maintained a keen interest in steam-powered transportation—ships and trains—throughout his life. He illustrated the 1989 book *The Royal Australian Navy: The first seventy-five years* with twenty-six paintings and several drawings.

Chuck Boie, b. 1941

Boie had a long career as a graphic illustrator in Milwaukee, working for several years at Ad Arts before co-founding Art Factory with partner Tom Nachreiner. They worked with advertising studios and magazines as well manufacturing companies, and Boie was their transportation expert. He had become interested in art during elementary school, and he also loved trains, planes, and cars from an early age. He grew up a block from the Milwaukee Road in West Allis and attended the Layton School of Art (now the Milwaukee Institute of Art & Design) in Milwaukee.

Allen J. Brewster, 1935–2002

Brewster did work for Kalmbach both as a freelancer and a staffer, beginning with *Model Railroader* in 1965. His two employment stints spanned 1969–1975 and 1981–1986. In between, he was a project engineer for Rockwell International at Rocky Flats, Colorado. He came from a family of Santa Fe railroaders, which he wrote about in the February 1986 *Trains*. At Kalmbach, he won plaudits from both colleagues and readers for his highly detailed cutaway engineering drawings of railroad equipment, accented in color with his deft use of an airbrush.

Kent Day Coes, 1910–2000

Coes had a three-decade career at McGraw-Hill Publications, retiring in 1975 as art director of two of its periodicals. He was born in Chicago and grew up in Newton Center, Massachusetts, where the big tank engines that the Boston & Albany used in commuter service left deep impressions. He attended New York University and studied at the Art Students League and the Grand Central School of Art. He was also a photographer, but he preferred to paint from memory—and to create effects that were not possible in photography. His picturesque watercolors won many awards, and he continued to paint railroad scenes throughout his life.

Howard Fogg, 1917–1996

Fogg is often referred to as the dean of American railroad artists. He said of himself that he wasn't an artist who painted trains, but a railroader with a paintbrush. He received a B.A. degree in English from Dartmouth and then attended the Chicago Academy of Fine Arts. During World War II, he served with distinction as a fighter pilot in the Army Air Corps, flying seventy-six combat missions over Europe. After the war, he worked twelve years as an illustrator for the American Locomotive Company. In 1955, he moved with his wife, Margot, and their three sons to Boulder, Colorado, where he worked independently as a railroad artist until his death. His vast output includes more than seventy paintings for Leanin' Tree greeting cards and numerous commissions by railroad companies and executives, as well as authors and publishers.

Olindo "Lindy" Giacomini, 1930–1989

Giacomini was an artist in the Milwaukee area. His commercial work included illustrations for puzzles and teen fiction books.

George A. Gloff, 1932–2012

Gloff grew up on Milwaukee's west side along the city's Route 16 streetcar line, a fortuitous fact given his lifelong interest in electric traction. He attended Milwaukee's Boys Tech High School and later studied at the city's famed Layton School of Art, which later became the Milwaukee Institute of Art & Design. One of his first jobs was doing graphic design for Milwaukee's Speedrail interurban company. He joined Kalmbach Publishing Co.'s art staff in 1951 and became corporate art director in 1962, serving in that role, as well as on the company's executive committee, until he retired in 1991. In addition to his accomplishments as a painter and magazine designer, he was a masterful cartographer, known for meticulously rendered, large-scale railroad maps.

Steven R. Krueger, b. 1946

Krueger is an amateur artist who has loved drawing since he was a boy. His childhood took him from Minnesota to Illinois to New Jersey to Oklahoma, where he attended college at Phillips University. While there, he worked summers for the St. Louis–San Francisco Railway (the "Frisco") as a brakeman and switchman. He spent two years in Germany with the army, where seeing steam locomotives in regular service further piqued his railroad interest. He began painting watercolors after he returned to Oklahoma.

Lawrence "Larry" O. Luser, 1941–2004

Luser (pronounced "lusser") had a thirty-eight-year career in Kalmbach's art department. He had studied at Milwaukee's famous Layton School of Art (now the Milwaukee Institute of Art & Design) and designed many of Kalmbach's how-to hobby books, as well as some of its hardcover railroad

books. *Folio* magazine recognized Luser with an Ozzie Award for Design Excellence for his work on Kalmbach's short-lived *Trains Illustrated*. He died at age sixty-three, just four years after retiring.

Marshall Patrick "Pat" McMahon, 1931–1986
McMahon worked as an illustrator for the *Minneapolis Star-Tribune* newspaper and also painted wildlife scenes. He grew up in Eau Claire, Wisconsin, and was a long-time member of the Chicago & North Western Historical Society, whose *North Western Lines* magazine also published his work. He died tragically in a boating accident when he was just fifty-four years old.

Gilmore "Gil" Reid Sr., 1918–2007
Reid worked in Kalmbach's art department from 1957 until 1978, ultimately becoming the company's assistant art director. He grew up along the Pennsylvania Railroad in Indiana, and he studied art at both the Chicago Academy of Fine Arts and Miami University. He also served in the Army's 10th Engineering Battalion during World War II, receiving a Purple Heart. He continued painting trains and railroads long after his tenure with Kalmbach, becoming one of the country's foremost railroad artists. His vast railroad oeuvre includes creating the artwork for nineteen years of Amtrak calendars.

Ted Rose, 1940–2002
Rose was a gifted artist who worked summers in the Kalmbach art department while studying art at the University of Illinois. He grew up in Milwaukee, where he learned about art from his father, an architect, and about railroading from the Milwaukee Road, Chicago & North Western, and North Shore. During his late teens and early twenties, he traveled all over North America photographing steam locomotives. Following army service in Vietnam, Rose settled in Santa Fe, New Mexico, and worked as an illustrator for the city. After a decade-plus hiatus, he resumed painting trains around 1980 and worked feverishly until cancer claimed him at the age of sixty-one.

Robert "Bob" M. Sherman, 1912–1993
Sherman spent ten years of his career as an illustrator for Lionel Trains in their advertising department. Kalmbach's *Classic Toy Trains* commissioned him to make three paintings, two of which appeared on the magazine's cover. He was born in New Jersey and credited his high school class in mechanical and architectural drawing as the basis for his work. He also attended the Art Students' Institute during high school and for another year after graduation. He grew up near the Erie Railroad, began drawing its trains, and sold many of his drawings to its railroaders. He worked for a number of ad agencies as well as Bell Laboratories during World War II. He also illustrated two Golden Books about trains, and he remained a Lionel collector throughout his life.

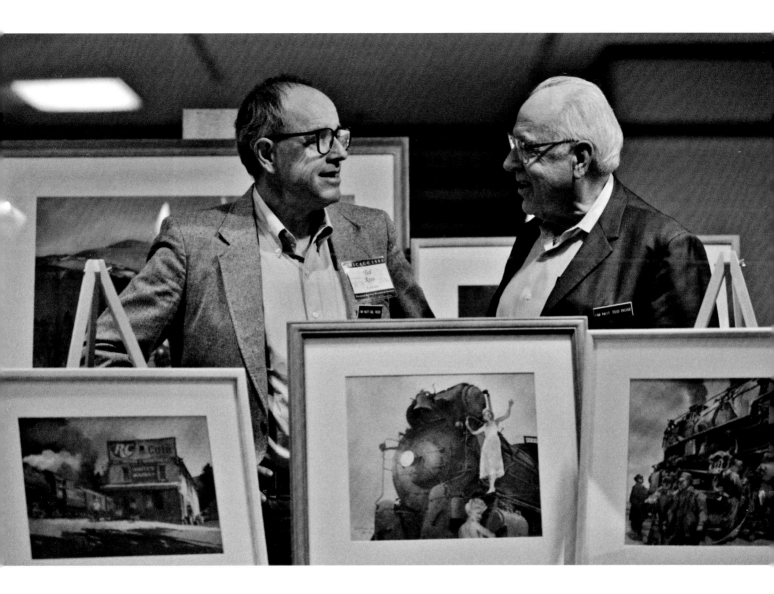

Ted Rose, left, and Gil Reid had adjacent tables at the National Railway Historical Society's 1993 convention in Chicago. As a joke, they wore matching nametags stating, "I'm not Gil Reid," and "I'm not Ted Rose." Photograph by John E. Gruber, collection of the CRP&A, Gruber-10-129-006

John Swatsley, b. 1937

Swatsley worked in Kalmbach's art department for five years in the 1960s and continued to do work for the company after that. He was born in Beloit, Wisconsin, and started drawing before he was three. While he was even more interested in railroads than art, he took art classes all through high school and then attended the prestigious Art Center School in Los Angeles—after seeing an ad for it in *The Saturday Evening Post*. His tenure at Kalmbach began after military service in Vietnam; he worked for George Gloff, primarily for *Trains* magazine. He later married the daughter of a Kalmbach employee and maintained friendships with others from the art department, especially Gil Reid. His distinguished career in art and illustration included winning first place in the United States Forest Service's centennial stamp competition.

Richard Ward, 1916–1993

Ward was a British artist whose paintings appeared frequently in *Trains* magazine in the 1950s. He was self-taught and worked primarily in watercolors. He served in the Royal Air Force during World War II and later produced aircraft illustrations for the Profiles series of magazines and cards for British printing company Noel Tatt. •

Kalmbach Interviews

Interviewer:

Lisa Hardy, program administrator, Center for Railroad Photography & Art

Interview subjects:

Kevin P. Keefe, former editor, *Trains* magazine

David Lassen, senior editor, *Trains* magazine

Rob McGonigal, former editor, *Classic Trains* magazine

Brian Schmidt, editor, *Classic Trains* magazine

As CENTER STAFF BEGAN work on the Kalmbach Art Collection, we realized that speaking with former Kalmbach employees—including some who joined successor Firecrown Media—would provide invaluable context for the paintings and drawings. Through these interviews, some unexpected themes emerged: the importance of people and relationships, the significance of workplace culture, and the value of daily access to art.

The following are excerpts from interviews conducted in early 2025.

Hardy: How did the presence of this art collection shape the creative culture of the magazine's workspace and impact the people who interacted with it on a daily basis?

Schmidt: I certainly look at publishing a little bit differently because this art came from the era where color photography wasn't as clear and wasn't as widespread. Kalmbach could and would commission these paintings for a book cover because they didn't have the color photo that they wanted, but they could go out and create that perfect image. As an editor now, I look for the best photo available for my cover or for a story. Back then they made the best image that they could because they hired someone to do it.

Lassen: For me, [the art] always reminded me that we were part of something bigger than that moment. Kalmbach had been around for a long time and had this great reputation…and had contributed a lot to the rail industry and its history. It kind of made me feel like we had some responsibility to try to carry that on. The other impression [the art] always made was when we had visitors, the two things they probably most enjoyed were the big model train layout and the art on the walls. … The art was always there and you sort of took it for granted but…on a regular basis, things called it back to your attention that [the art] was a really significant part of Kalmbach's legacy. It showed that there had been great work done here, and it was up to us to keep carrying that on.

McGonigal: I don't think you could help but be influenced [by the art]; every major wall surface had a painting or a piece of artwork on it. [The art] was in the atmosphere, it was in the air. The culture was great, everyone was very welcoming, especially the people I worked with. It was a good, supportive place to work.

Keefe: All of us who had any kind of connection to railroading were always aware of who these [artists] were; we probably knew instinctively where [the artworks] were published and under what circumstances…to us in the railroad field, especially in *Trains*…we knew Gil, we knew Ted, we knew a little bit about Swatsley, we knew Gloff, we knew all these people, or knew

of them. A lot of us grew up looking at this stuff before we even came to work at Kalmbach. You'd walk around the halls of a place like this and were reminded of the legacy of the company. And you'd feel tied, at least I did, to that legacy and a certain responsibility to hold up that kind of quality and keep the tradition going.

Hardy: What are your thoughts about the collection overall?

Schmidt: When I started in 2012, Kathi Kube, who was the managing editor at the time and my boss…said you can always find your way around the building if you look where artwork is. The birds are down by the birder magazine, snowmobiles are by *American Snowmobiles*…it was great and she was right until I realized that trains were everywhere in the building and you [could] still get lost. That was just something that Kalmbach recognized that the company was built on railroads and railroading, and that art was pervasive throughout the building. But when you were trying to navigate by it, it didn't help so much.

Lassen: [The art] gave us all a sense of where we were coming from and what we were doing, and there was a permanence to it. It drove you to be good. It was such a reminder every day that there had been great people who had worked [at Kalmbach] in all parts of our business—the writers, photographers, artists—there has always been a lot of excellence here and I think we all try to maintain it.

McGonigal: I'm delighted that the collection is saved and under the care of the Center. There is no better place for it to be. I'm glad that for almost thirty years I got to interact with it and see it in person on a regular basis.

Keefe: I can tell you I'm very pleased that all of these paintings were kept together. When Kalmbach liquidated, I was very afraid of what might happen because I think in a lot of ways [the art] was the best representation of the company's legacy as a ninety-year publisher. The greatest legacy of the company certainly are tens of thousands of magazines in libraries and homes across the world that entertained literally a few million people over the course of those ninety years. So that's the number one legacy, but number two, I think, is this art. Because the art says something about the people that worked here and the kind of people they wanted to work with, and the finished product speaks for itself.

Listen to the full interviews on our website: railphoto-art.org/exhibitions/kalmbach

CRP&A Staff Perspectives

ALL OF US AT THE Center for Railroad Photography & Art are thrilled to have accessioned the Kalmbach Art Collection into our permanent holdings. Our community's joyful reaction to our announcement in August 2024 reinforced my sense that Kalmbach publications hold a special place in our members' hearts. Many responses to our social media posts brimmed with youthful exuberance and fond memories of how nascent interest could blossom into full-blown fandom through early exposure to *Trains* magazine and books like *The Nickel Plate Story* and *The Mohawk that Refused to Abdicate*.

This was all really delightful to see play out online. For me, however, the most exciting part of the accession is that it contains a veritable who's who of the railroad art scene, including Howard Fogg, Gil Reid, and Ted Rose. While they were already represented elsewhere in our archive by small accessions or single works, here they are all tied together under a single provenance and purpose. Together, the works in the Kalmbach Collection form a narrative of what Kalmbach's editors and designers thought would incite excitement (and sales) among their readers. Preserving all the works in the collection together at the Center enables us to share that story.

As our largest fine art accession to date, the Kalmbach Collection also presented us with an invaluable opportunity to update some of our practices and facilities to accommodate the specific needs of graphic works on paper. Preparing the collection for exhibition (as well as long-term archival storage), for instance, required a thorough preservation screening of each framed piece, which often led to re-matting or re-framing. In addition, digitizing the collection was a great first test of our recently acquired oversized flatbed scanner. Further, the challenges posed by creating color-accurate digital surrogates of the paintings motivated us to introduce color management into our digitization workflow. Finally, the arrival of the collection prompted us to expand our archival storage; we added twenty-five new hanging racks to the second room of our three-room storage suite.

Planning of the exhibition and this publication began even before our board approved taking on the collection—an exciting opportunity with a fast turn-around. The timelines for developing the exhibit as well as processing the collection were considerably condensed, necessitating close cooperation between our entire staff. We worked together to transport the paintings from Kalmbach's former offices to our archive, and later from there to the Grohmann Museum. We pooled our collective knowledge to tackle exhibition policy updates, inventories, labels, this publication, and more. The project has been a great chance for our staff to gain a greater sense of fellowship and collaboration, along with a better understanding of each other's professions and perspectives along the way. For that, and so many other reasons, I'll always be thankful for my involvement with this collection, exhibition, and publication.

—Adrienne Evans, Director of Archives and Collections

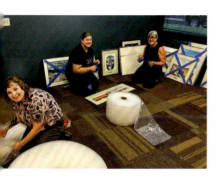

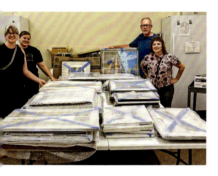

Adrienne Evans, Lisa Hardy, and Inga Velten pack the Kalmbach Art Collection at the company's former offices in Waukesha, Wisconsin, in July 2024. Photograph by Kevin P. Keefe

Velten, Hardy, Keefe, and Evans with the collection at the CRP&A archive. Photograph by Gil Taylor

Hardy packs the collection for the Grohmann Museum in March 2025. Photograph by Adrienne Evans

AS A NEWCOMER TO THE IMAGERY and art of trains, initially I did not grasp the significance of the Kalmbach Art Collection. I hadn't grown up seeing the artwork in *Trains* magazine or Kalmbach books. My journey began at what is considered the end of an era.

I remember that hot, humid July day in 2024, walking through the quiet, nearly empty corporate offices of Kalmbach Media. My introduction to this legendary publisher was through silence—an echo of what had once been a vibrant beehive of activity. I was there to help package the artwork for its move to the Center's archive in Madison, Wisconsin. At the time, my only connection to the art was the task of carefully wrapping each piece to ensure a safe journey. But once we had delivered the collection to our storage facility, my connection truly began.

The first questions Center staff asked were: How do we honor the Kalmbach name and this remarkable collection? What stories do we want to tell? To me, a great exhibition tells memorable stories and engages the senses—it's immersive. I began to wonder, could this artwork offer that kind of experience?

As our collections team began digitizing the art, I became more familiar with each piece. I learned how many of them had been created for stories in *Trains* magazine or book covers, and how deeply readers remembered them—recalling the exact issue, date, and accompanying article. I realized that Kalmbach editors had already created immersive experiences by thoughtfully pairing words with imagery. Decades later, readers still remember both the art and the story.

In December 2024, the Center finalized an agreement with the Grohmann Museum to host the first public display of the Kalmbach Art Collection, opening in just six months in May 2025. It was a thrilling milestone, but we still needed a name. One day, while stuck in traffic, I found myself thinking about the editors whose vision left such a lasting impression. That's when it hit me. I called Scott Lothes, our executive director, and said, "Scott, I've got it—the name should be *The Kalmbach Art Collection: Pairing Words and Imagery*."

Since then, I've delved even deeper into this collection and come to appreciate how special it is that the Center now cares for it. I'm endlessly grateful for my involvement in preserving and presenting this imagery. I've become immersed in the art and feel a particular sense of pride knowing that we are honoring not just the Kalmbach name, but also the people—editors, writers, designers, and artists—who brought this imagery to life for generations of readers. My hope is that this exhibition not only continues the immersive experiences that began in the pages of Kalmbach's publications, but that it also inspires new generations to feel the same wonder, connection, and curiosity that these images once sparked.

—Lisa Hardy, Program Administrator

About the CRP&A

Board of Directors

T. Bondurant French, chair
David Kahler, vice chair
Scott Lothes, president
Michael Schmidt, secretary
Nona Hill, treasurer

Ronald L. Batory
Eric Baumgartner
Jeff Brouws
Norman Carlson
Betsy Fahlman
Justin Franz
Todd Halamka
Kevin P. Keefe
Albert O. Louer
Peter J.C. Mosse
Richard Tower
Davidson Ward

John E. Gruber, 1936–2018,
founder, director emeritus

Staff

Jordan Craig,
 digital projects coordinator
Adrienne Evans,
 director of archives
 and collections
Lisa Hardy,
 program administrator
Natalie Krecek,
 processing archivist
Elrond Lawrence,
 marketing and
 acquisitions coordinator
Scott Lothes,
 executive director
Shelby Shull,
 administrative assistant
Heather Sonntag,
 associate archivist
Gil Taylor,
 reference and
 processing archivist
Inga Velten,
 development director

FOUNDED IN 1997, the Center for Railroad Photography & Art (CRP&A) is a 501(c)(3) national not-for-profit arts and educational organization based in Madison, Wisconsin. As its mission the CRP&A "preserves and presents significant images of railroading," securing them in its archive and interpreting them in publications, exhibitions, and on the internet.

The CRP&A conducts its programs both in-house and with numerous partners throughout the country. Collaborations include the landmark Chicago History Museum exhibition, *Railroaders: Jack Delano's Homefront Photography*, and 2019's *After Promontory: 150 Years of Transcontinental Railroading*, which has visited a dozen venues throughout the western United States, including the Brigham Young University Museum of Art. The CRP&A also mounts and circulates traveling exhibitions about specific themes in railroading as well as individual photographers and artists such as Wallace W. Abbey, Joel Jensen, David Plowden, Ted Rose, and Jim Shaughnessy.

Efforts to preserve railroad photography and artwork have led to the CRP&A's amassing more than 600,000 images—with standing commitments for that many more to come. Its professional archives team preserves, digitizes, and makes available these images from its offices and storage facilities, sharing them through an online database and social media (follow @railphotoart). A committee of the board of directors reviews and makes recommendations to the full board for all potential additions to the archive.

In addition to books, the CRP&A publishes a quarterly journal, *Railroad Heritage*, featuring work by historic and contemporary photographers and artists. An annual awards program, named for principal founder John E. Gruber (1936-2018), recognizes and celebrates creative photography.

The CRP&A hosts an annual conference, called Conversations, typically in the spring in the Chicago area, where photographers, artists, historians, editors, and railroaders meet to view presentations, discuss their work, and address artistic and photographic issues. Additional programming is available through free monthly online presentations, delivered live via ZOOM and recorded for later viewing at: youtube.com/railphotoart

Members enable all of the CRP&A's programs and projects; its Legacy Society recognizes individuals who made provisions to support its work through their wills or estates. Learn more and join on the website: www.railphoto-art.org •